RE

BOOK

BY

D. SHRIGLEY

HAIR GROWING ON YOUR
EYES

CHRONICLE BOOKS
SAN FRANCISCO

FUCKING
SUN COMES UP EVERY FUCKING MORNING

First published in the United States in 2010 by Chronicle Books LLC.
First published in the United Kingdom in 2009 by Redstone Press.

Library of Congress Cataloging-in-Publication Data available.

ISBN: 978-0-8118-7430-4

Manufactured in China

This book was created during a residency at IASPIS, Stockholm, April–May 2009.

Layout Kim McKinney. Production by Tim Chester.

10 9 8 7 6 5 4 3 2 1

Chronicle Books LLC
680 Second Street
San Francisco, CA 94107
www.chroniclebooks.com

HORS D'OEUVRES

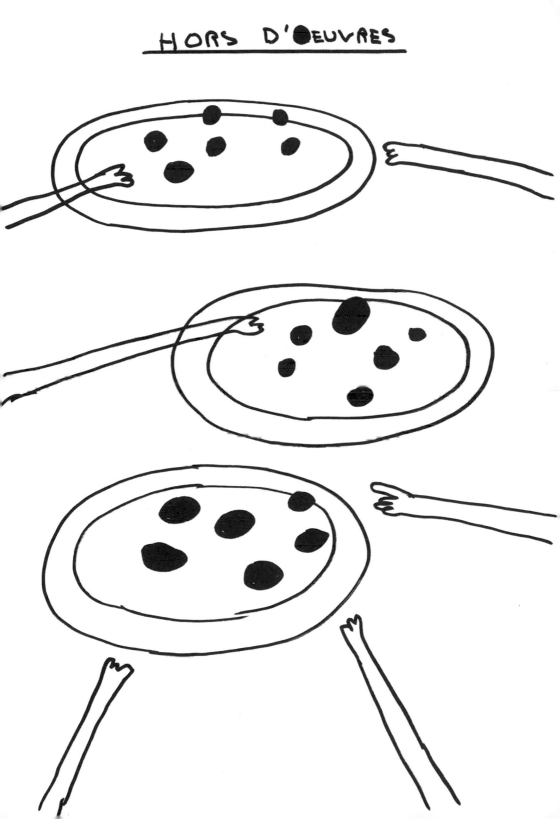

CHAPTER ONE

FAMILIARITY

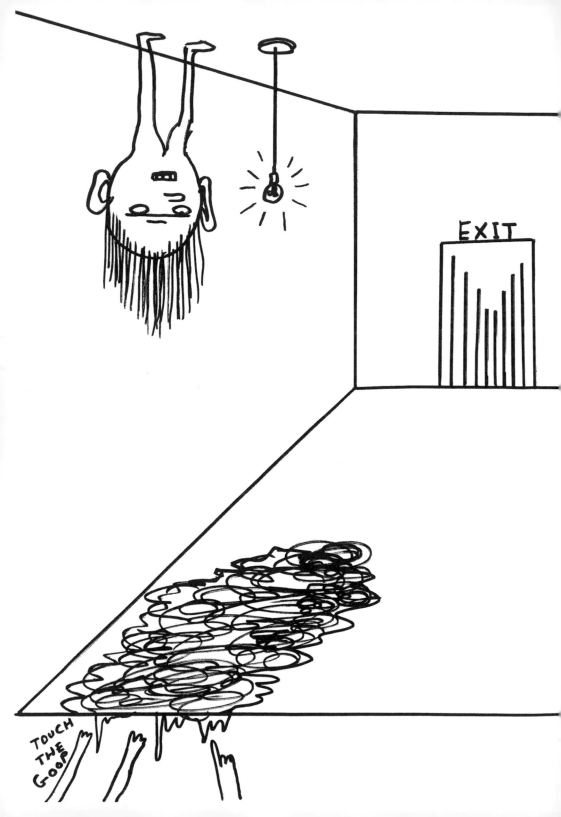

I HAVE FALLEN FROM A
GREAT HEIGHT
INTO THIS PUDDING
BUT DON'T WORRY
I AM O.K.

NUMBERS

NUMBERS

NUMBERS

NUMBERS

NUMBERS

NUMBERS

NUMBERS

NUMBERS

NUMBERS

NUMBERS

ARMS

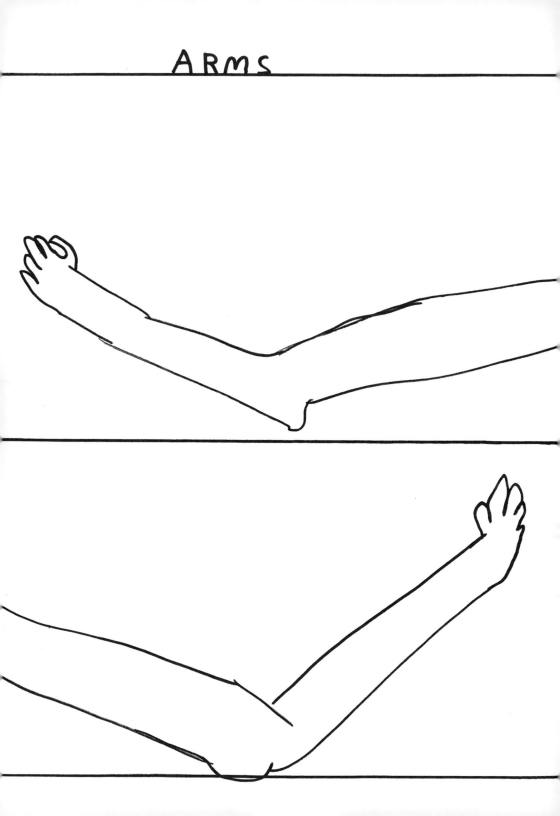

FRANCE →

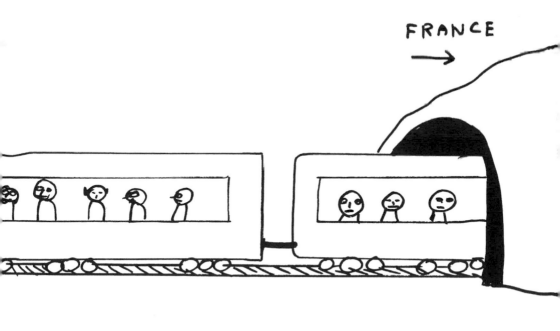

INTERESTS

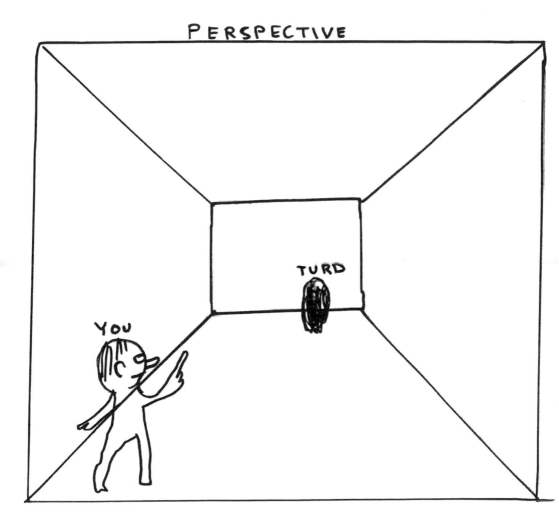

NAIL GUN

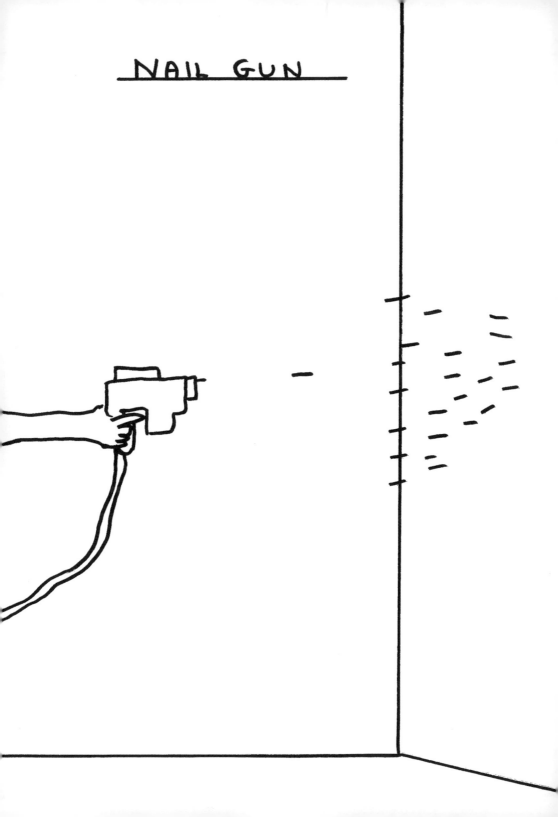

EYE COUNT

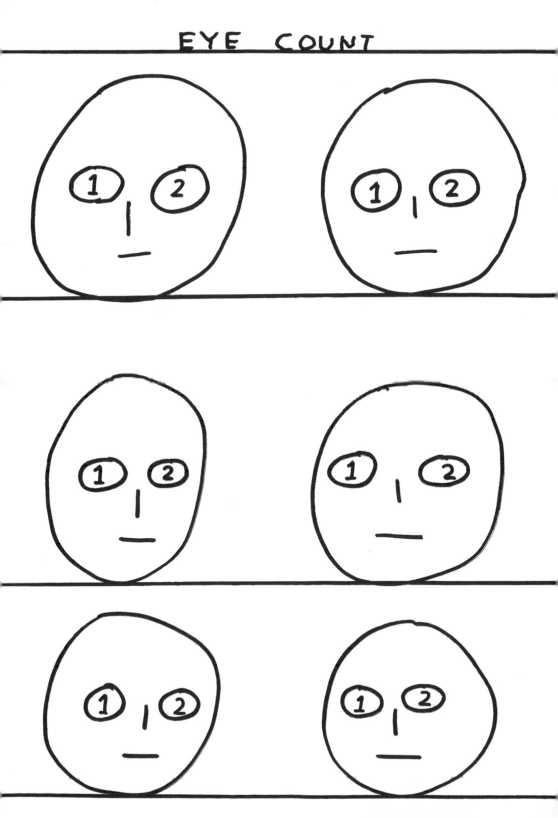

PHOTOGRAPHS

TIME

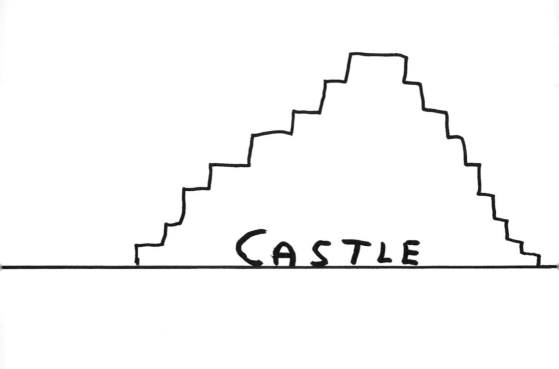

CASTLE

BUBBLE

I FIX YOUR BRAIN

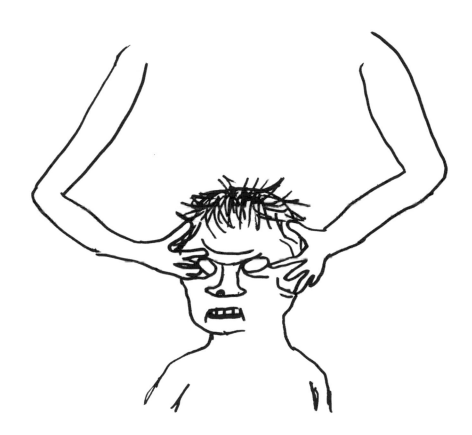

DREAM

DEATH

DOOM

DIE

DISEASE

~~DISEASE~~ DISINTEGRATION

DEGRADATION

DISAFFECTION

DOG SHIT

DIRE

DISFUNCTIONAL

DELICATESSEN

TRADITIONAL MEAL ?	NO THANK-YOU
WHY NOT TRADITIONAL MEAL ? IS DELICIOUS	NOT HUNGRY
WHY NOT HUNGRY?	SMELL OF MELTED PLASTIC

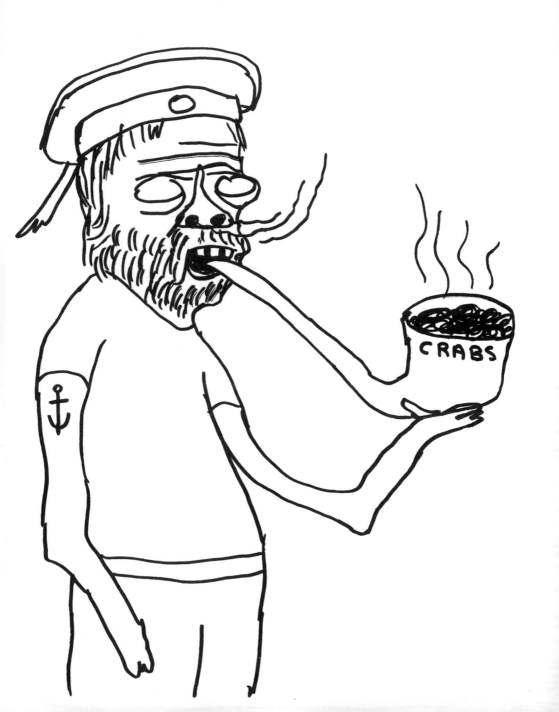

OUTDOOR SWIMMING POOL

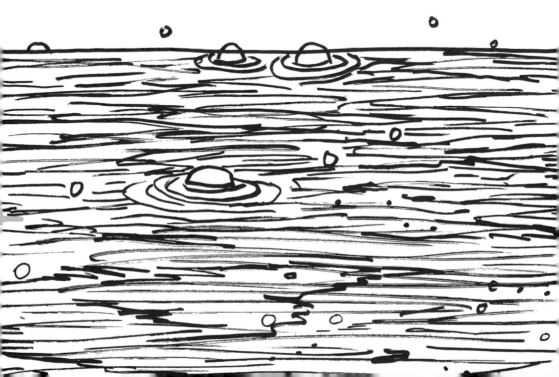

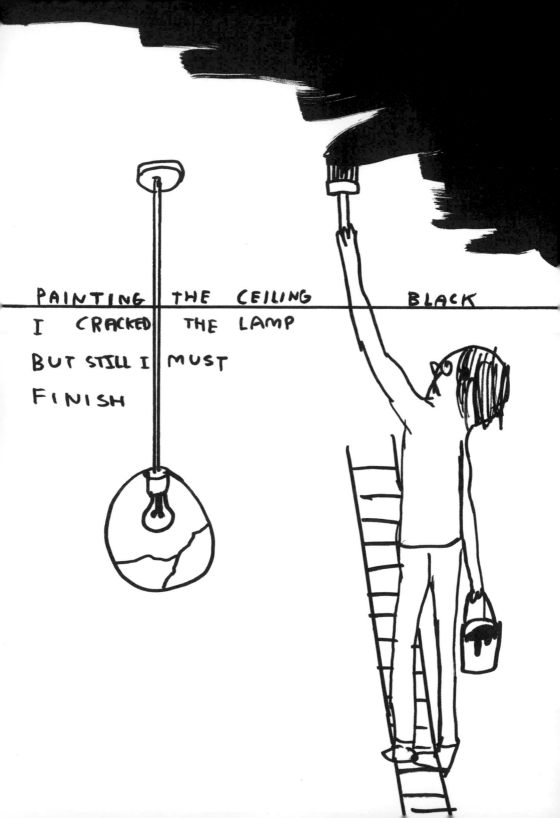

PAINTING THE CEILING BLACK
I CRACKED THE LAMP
BUT STILL I MUST
FINISH

I JUMPED IN THE RIVER

YOU JUMPED IN THE RIVER

I DID NOT INTEND FOR YOU TO JUMP
IN THE RIVER

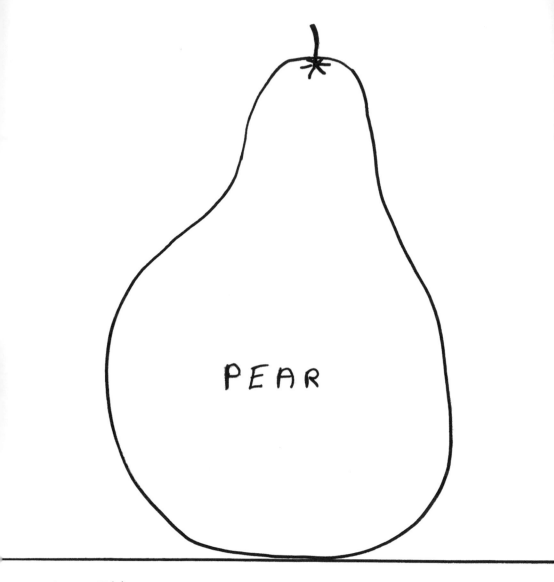

NOTHING WRONG WITH PEAR

I LOST MY EAR

IT IS POSSIBLE THAT

I MIGHT GET IT BACK
BUT I DON'T KNOW

HUMAN CANNONBALL

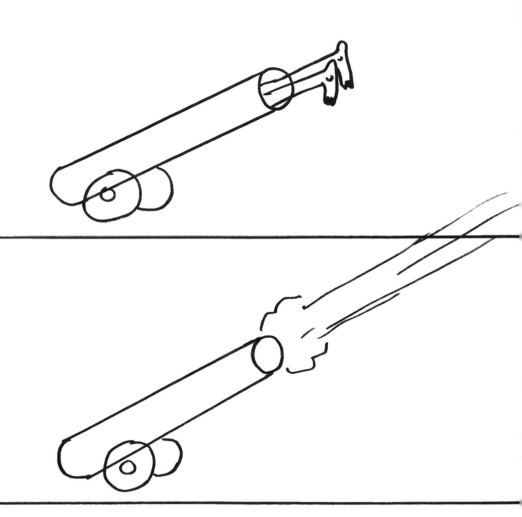

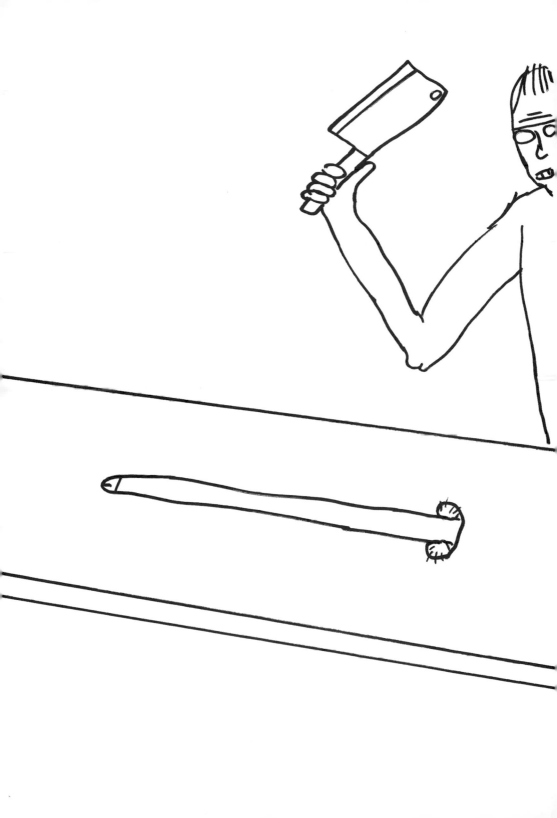

DEAR ARM,
PLEASE DO
AS I SAY
FROM NOW
ON. I AM
IN CHARGE.
YOU ARE NOT
IN CHARGE.
 SINCERELY,
 THE BRAIN

CRAZY TALK

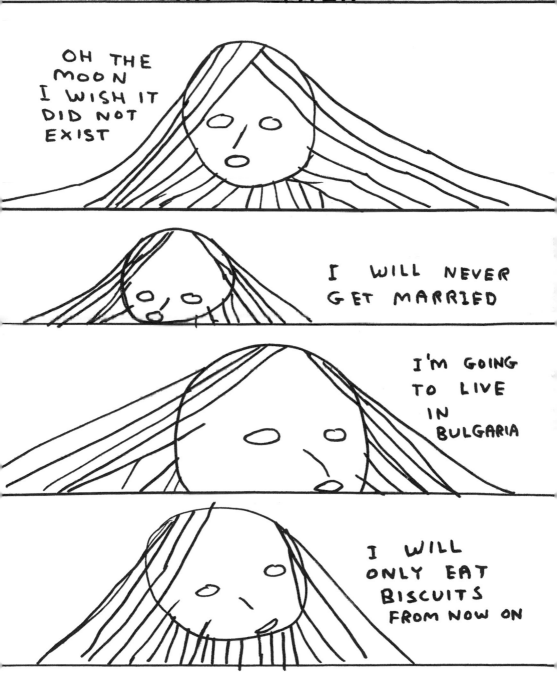

DROOL
FOR
PEACE

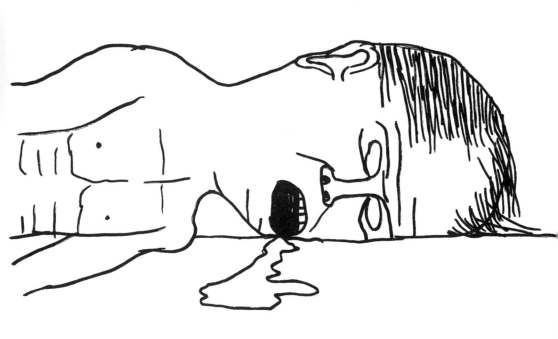

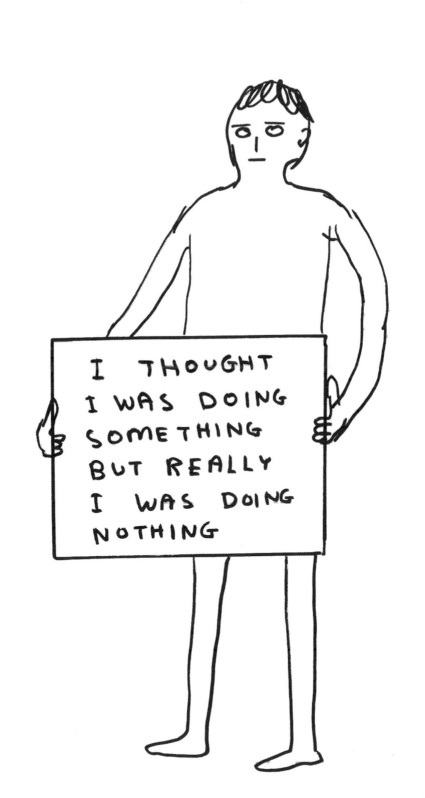

 HEAVY

FRIENDS
FRIENDS
FRIENDS
FRIENDS
FRIENDS
FRIENDS
FRIENDS
FRIENDS
FRIENDS
FRIENDS
FRIENDS

ENEMIES
ENEMIES
ENEMIES
ENEMIES
ENEMIES
ENEMIES
ENEMIES
ENEMIES
ENEMIES
ENEMIES
ENEMIES
ENEMIES
ENEMIES
ENEMIES
ENEMIES
ENEMIES
ENEMIES
ENEMIES
ENEMIES
ENEMIES

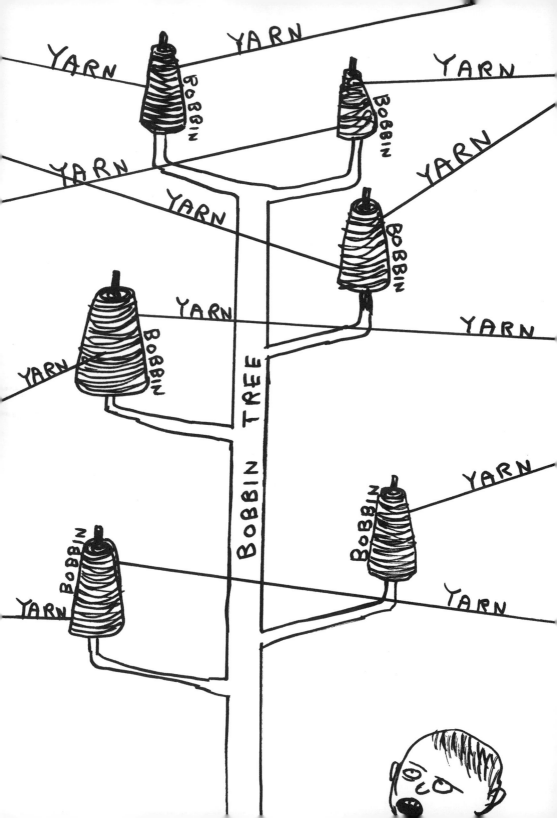

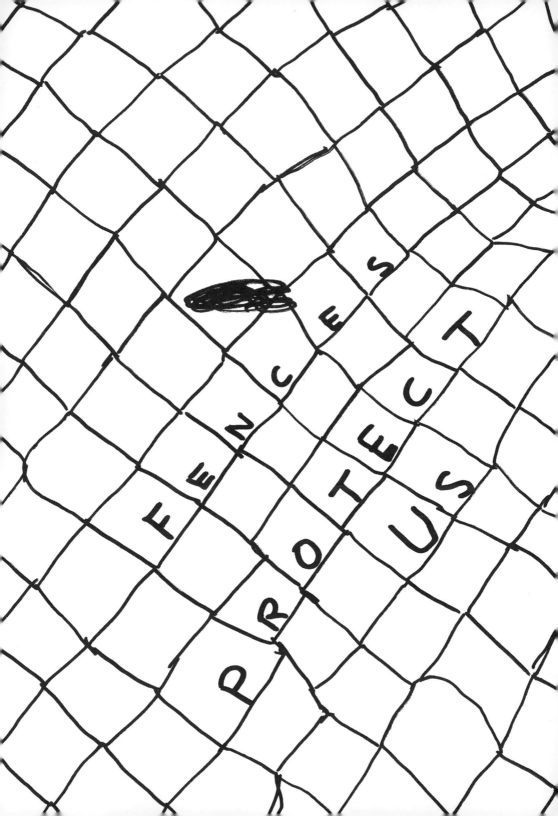

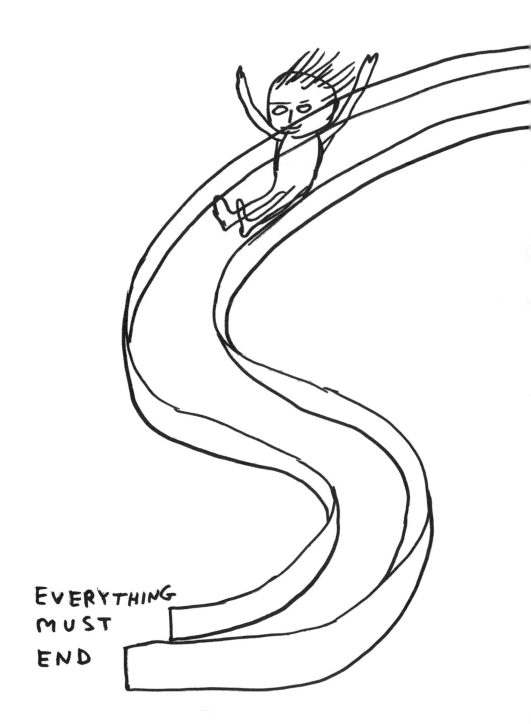

EVERYTHING
MUST
END

ARROWS ON THE ROAD

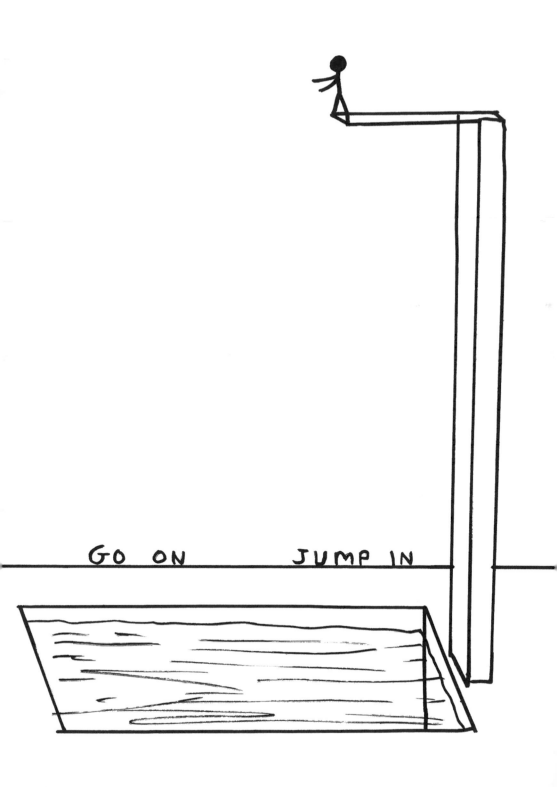

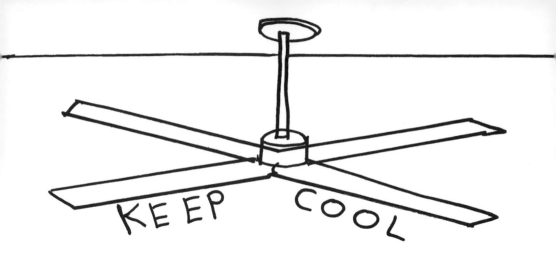

KEEP COOL

DON'T

GET HOT
AND GO MAD

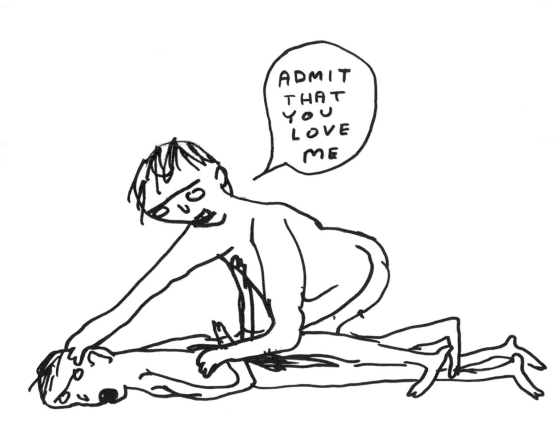

SWIPE YOUR CARD

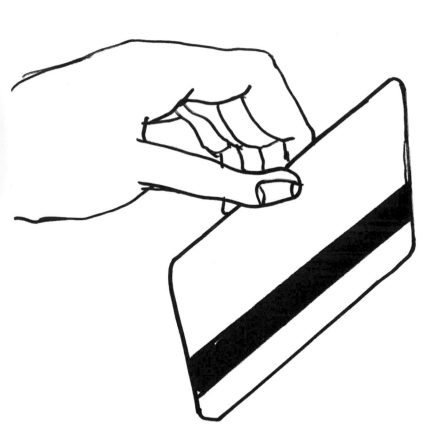

TAKE YOUR PILL

WORMS

CHAPTER

TWO

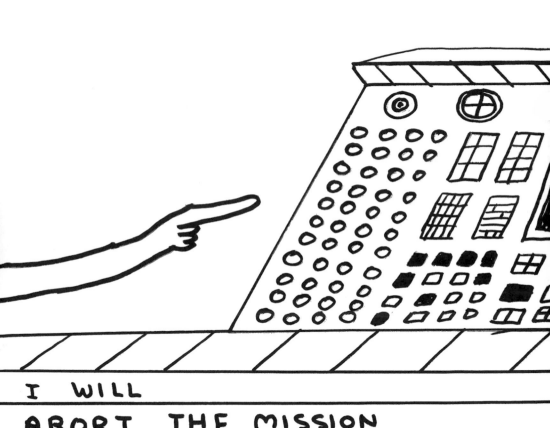

I WILL
ABORT THE MISSION

PORN SATELLITE

MAP
MAPA
CARTE
KARTE
MAPPA
KAPTA

LION
LEÓN
LION
LÖWE
LEONE
ЛЕВ

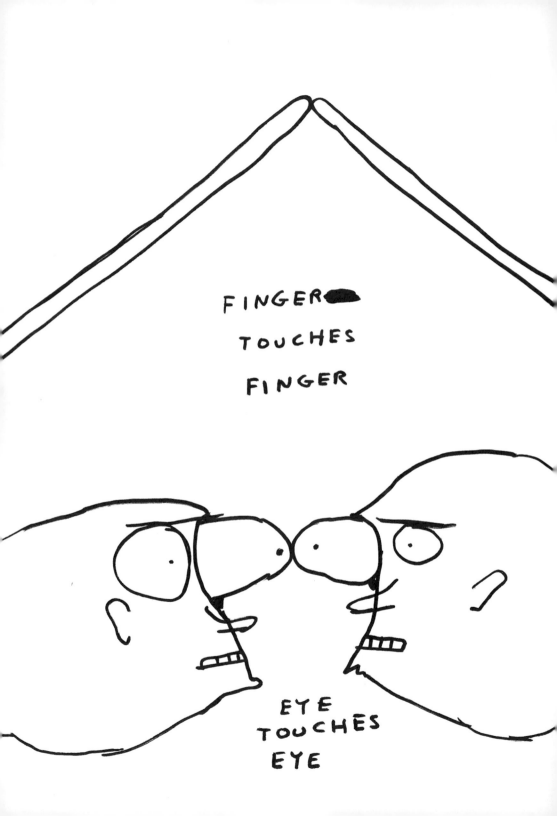

BIRTHING SPOON

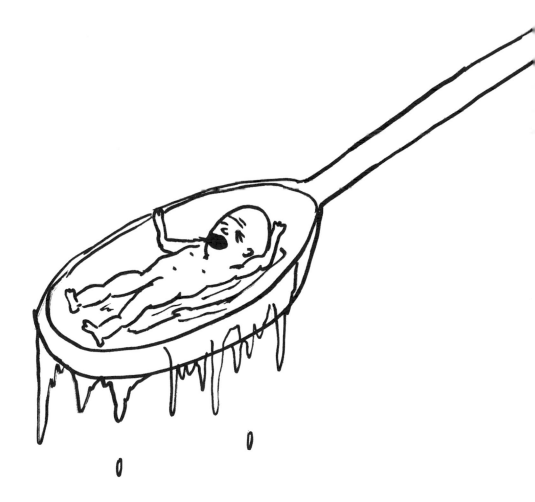

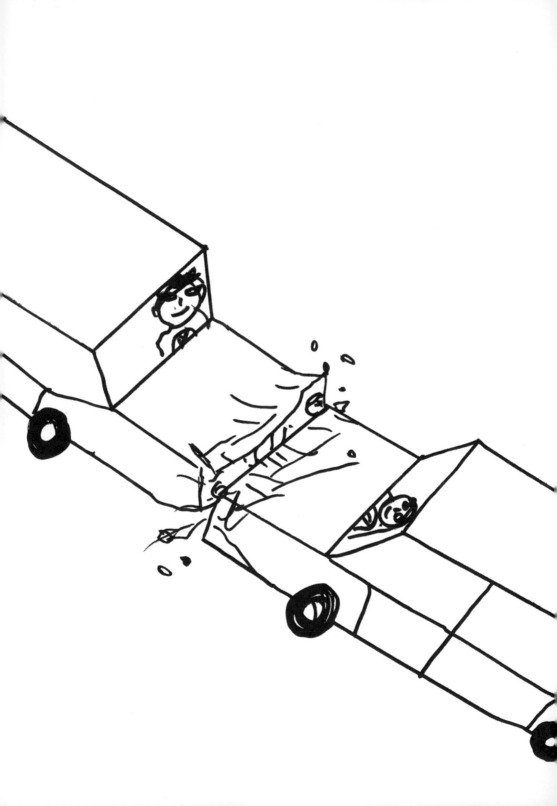

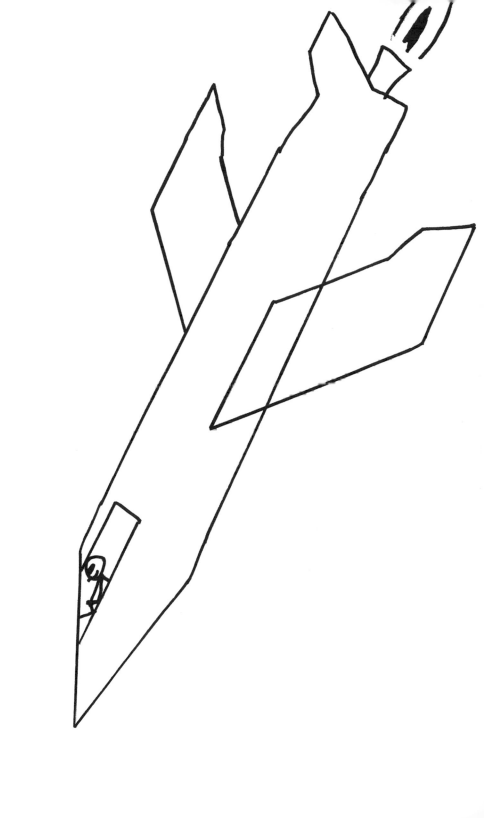

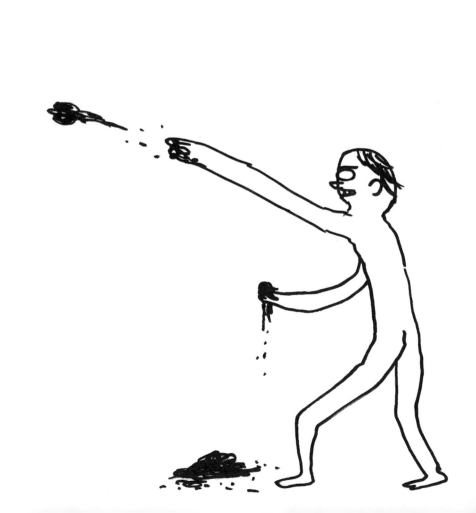

LIARS

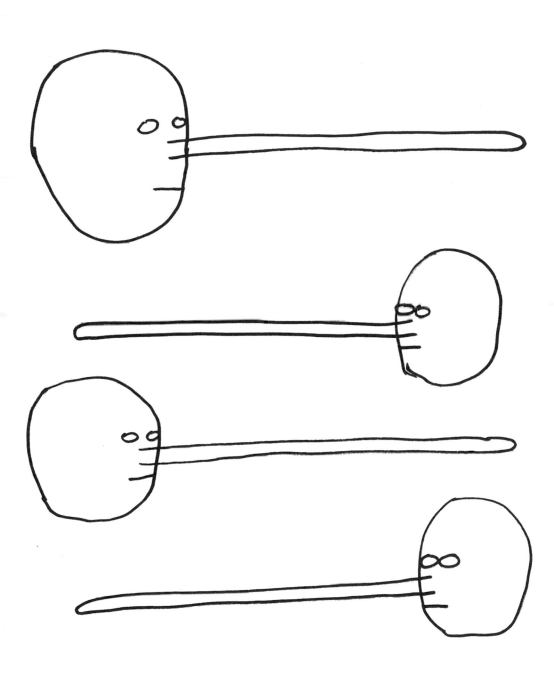

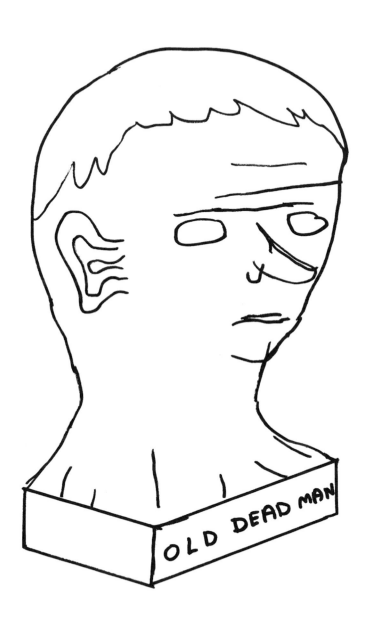

PLEASE FORGIVE ME
FOR BEING TERRIBLE

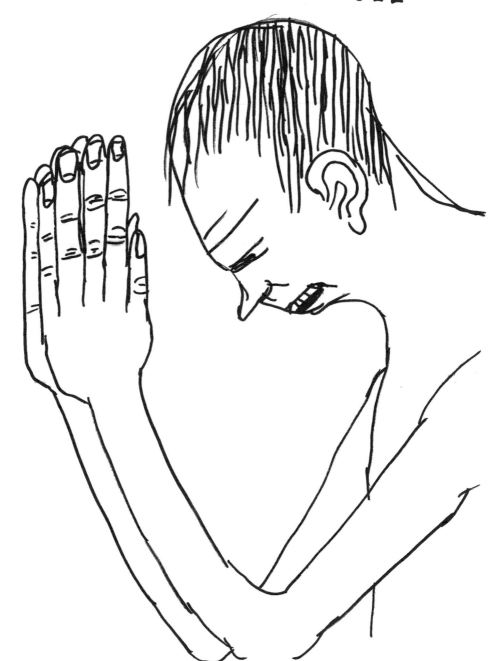

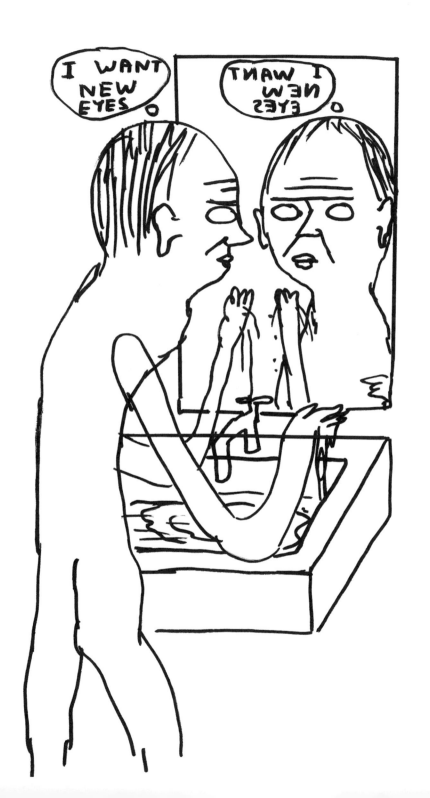

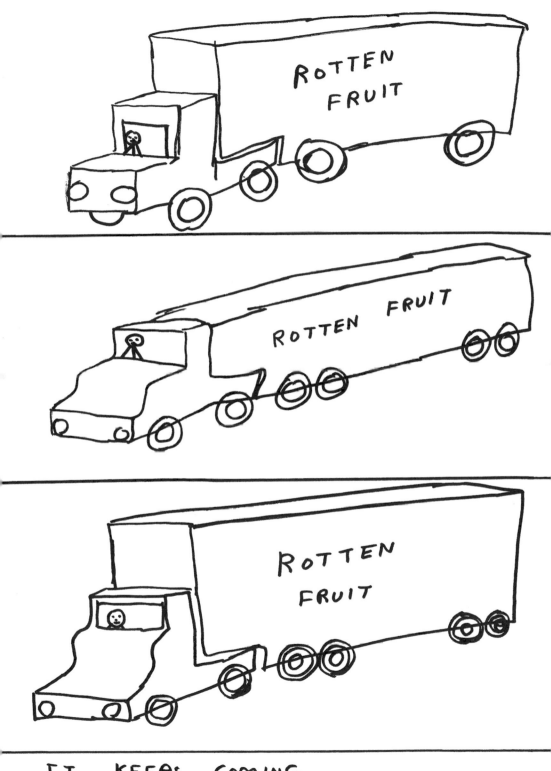

IT KEEPS COMING

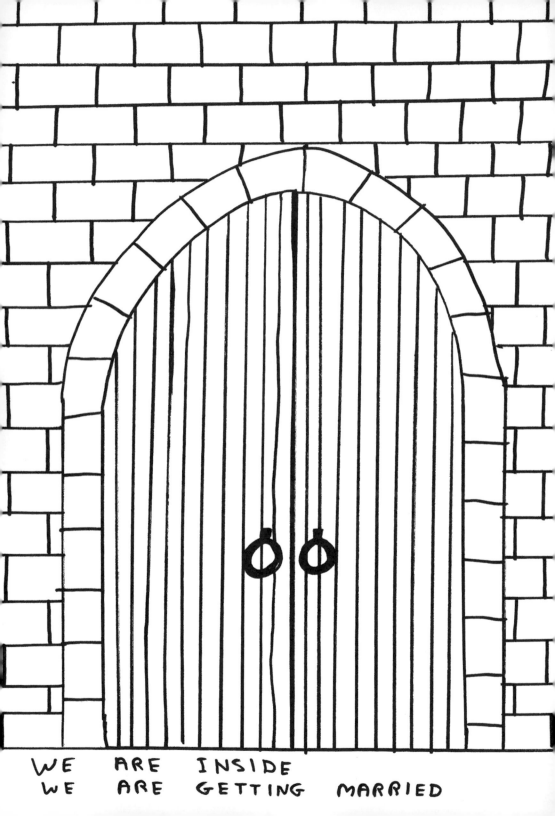

WE ARE INSIDE
WE ARE GETTING MARRIED

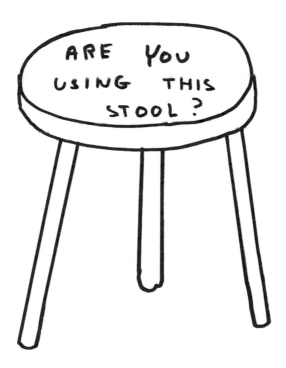

YES

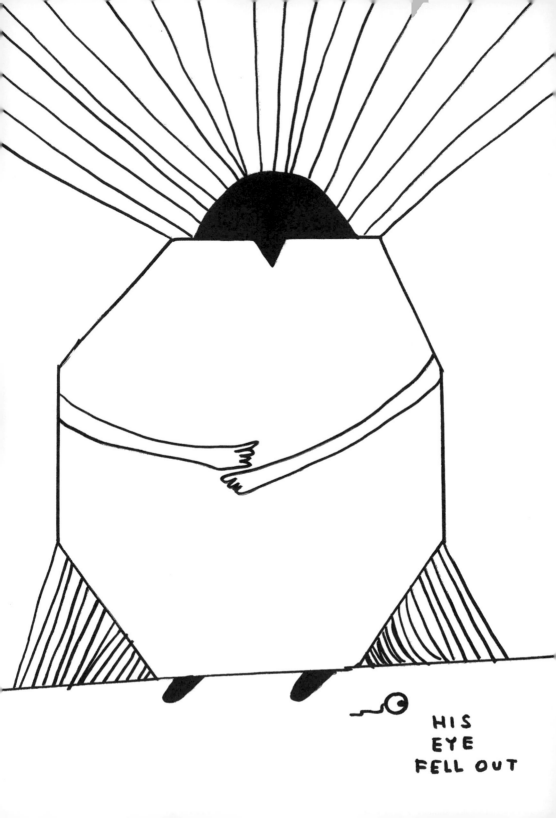

HIS
EYE
FELL OUT

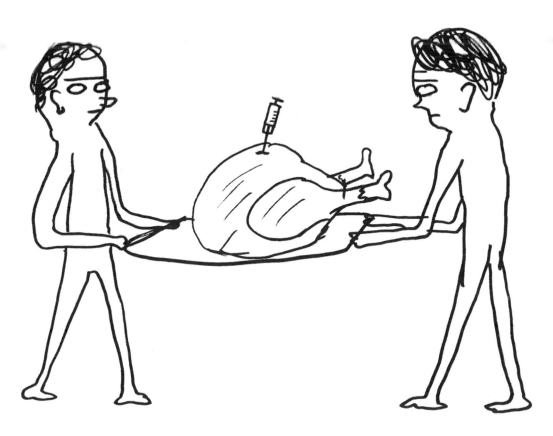

TEEN -AGER

THE GATES

THEY ARE WATCHING
WE ARE SUNBATHING

JOKES

NO ONE TO CATCH US

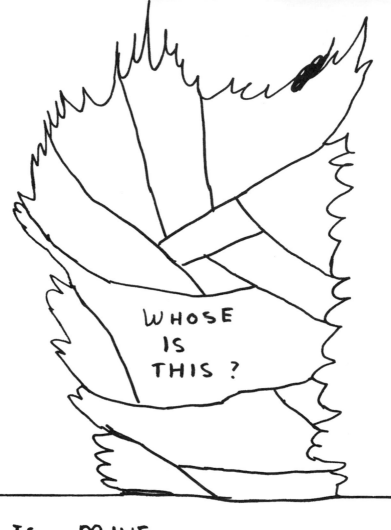

IT IS MINE

- PLEASE REMOVE IT FROM THE
PASSAGE

I CANNOT

- WHY NOT?

BECAUSE IT IS A LIVING THING WITH
ITS OWN WILL AND REFUSES TO
BE MOVED

GIANT BUG WATCHES SUICIDE

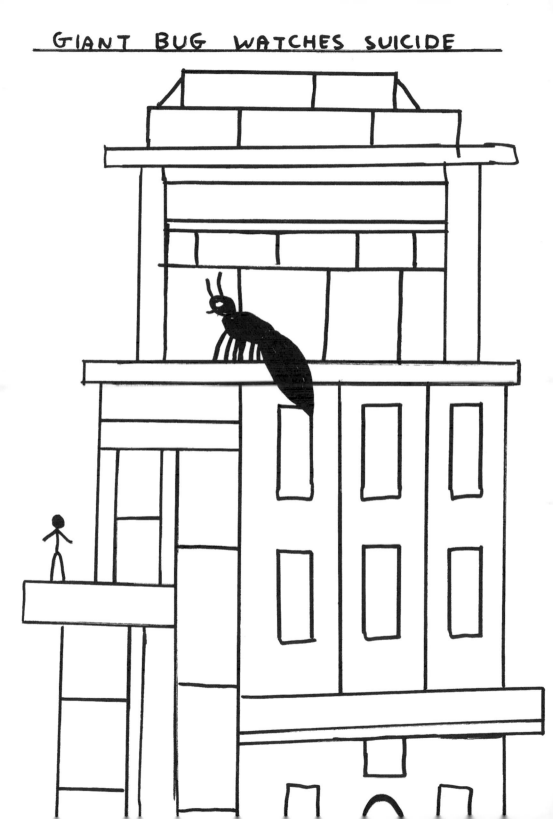

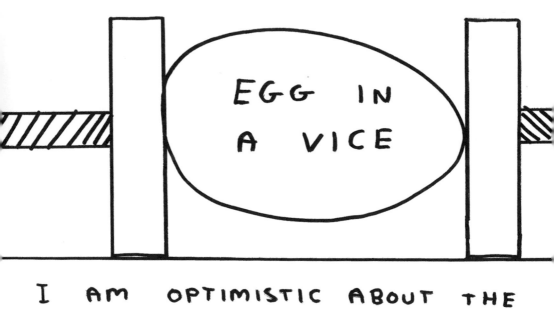

I AM OPTIMISTIC ABOUT THE
FUTURE OF THE EGG

FUCK OFF

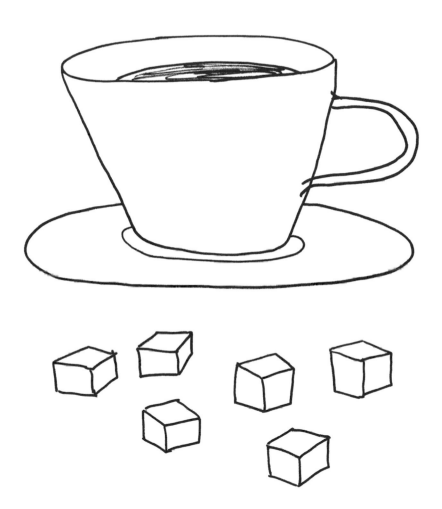

SIX LUMPS OF SUGAR IN

ONE CUP OF TEA

FIFTY CUPS LIKE THIS PER DAY
DON'T TELL ME I CAN'T

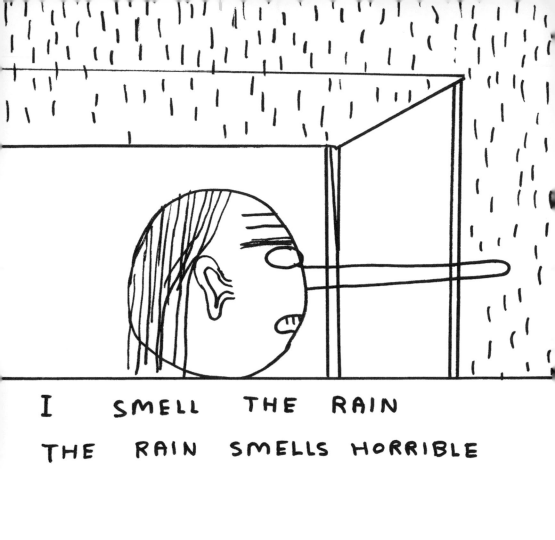

I SMELL THE RAIN
THE RAIN SMELLS HORRIBLE

OHHHHHH
AHH
OHHH
OOOOHH
OHH
AHHH
OH
AHHHHHHHHHH

AHHH
OHH
OOOH

AHHH
OHH
OHHH
OOOHH
AHH
OOHHHHHHH
AH

OOOOOHH
OHHH
AHH
OHHHHHHHH
OHHHHHHH
OHHHHHHH
OHHHHHHH

AHHHHHHHHH
AAAHHHHHHH
AAHHHHH
AAH
AH
AHHHHHHHHHH
OHHHH
AH

OHHHHHHHHH
OHHHHHHHH
OHHHHHHHH
OHHHHHHHH
OHHHHHHHH
OOOOOOHHH
OOOOOHHHH

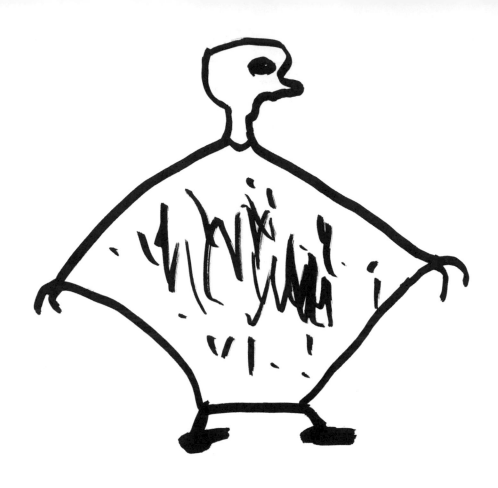

MY PONCHO WAS COVERED
IN BLOOD

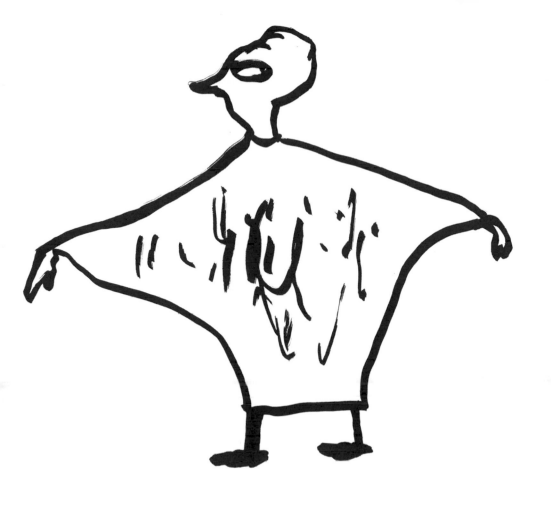

HIS PONCHO WAS COVERED
IN BLOOD

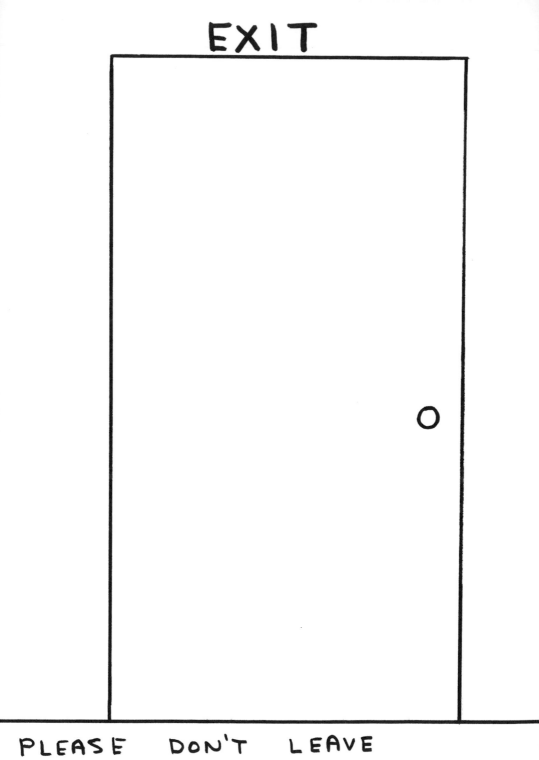

SALE

LEFT ARM

I PISS ON THEM EVERY DAY

ANGEL'S HEAD FELL OFF

IT SPINS AROUND

DAWN

I'VE BEEN

DANCING A MEANINGLESS DANCE

WITH STRANGERS

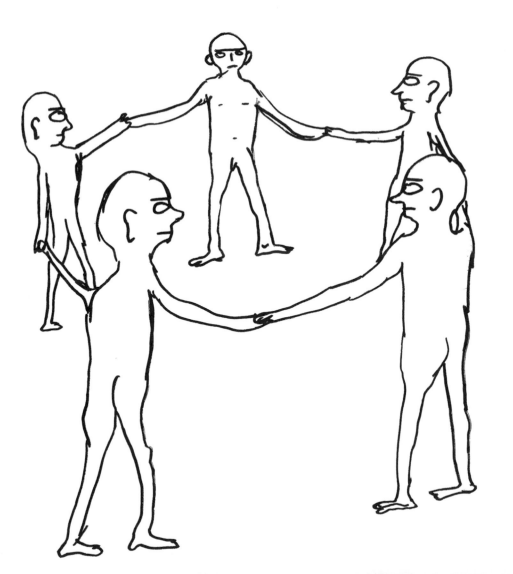

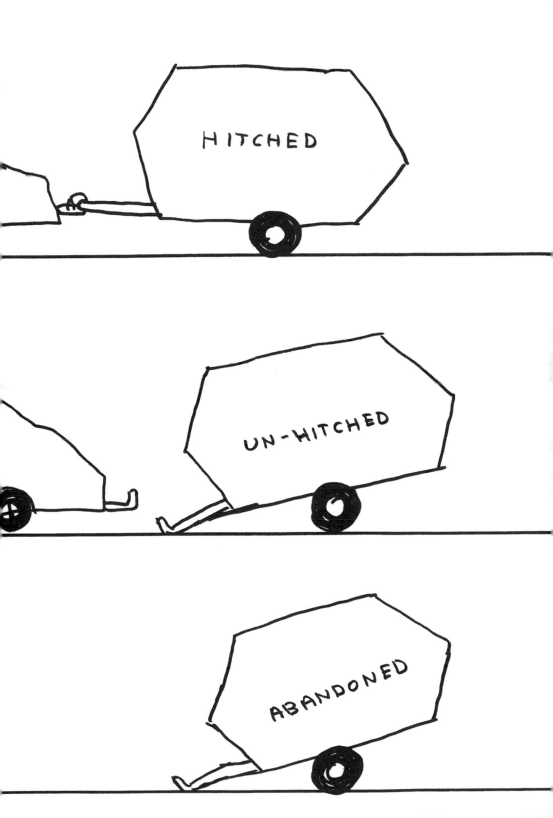

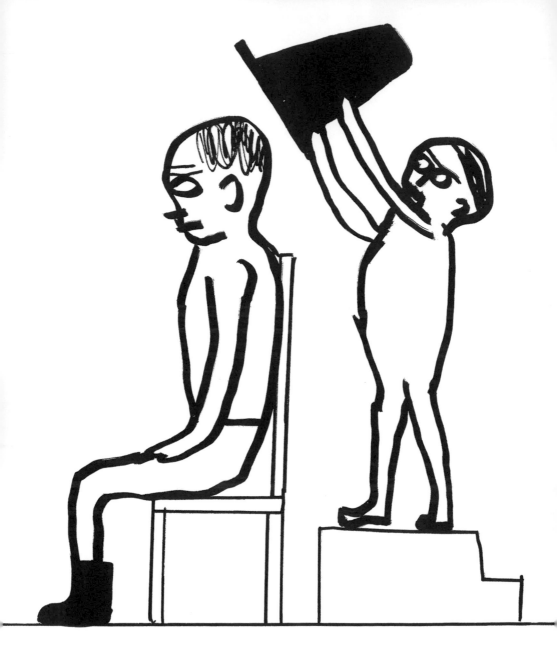

MY LORD WEARS A BLACK HAT
I AM TO PLACE IT UPON HIS HEAD
WHEN THE TIME COMES

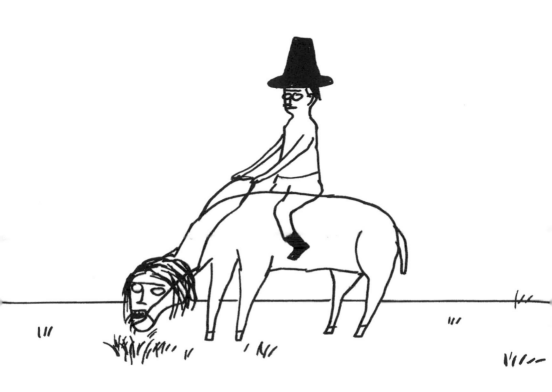

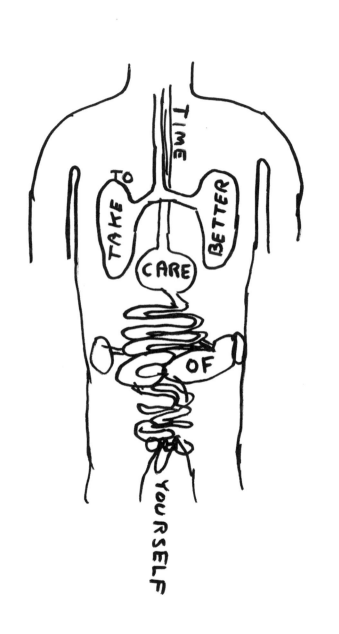

FORBIDDEN

BANANAS

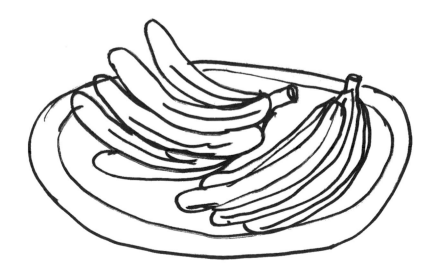

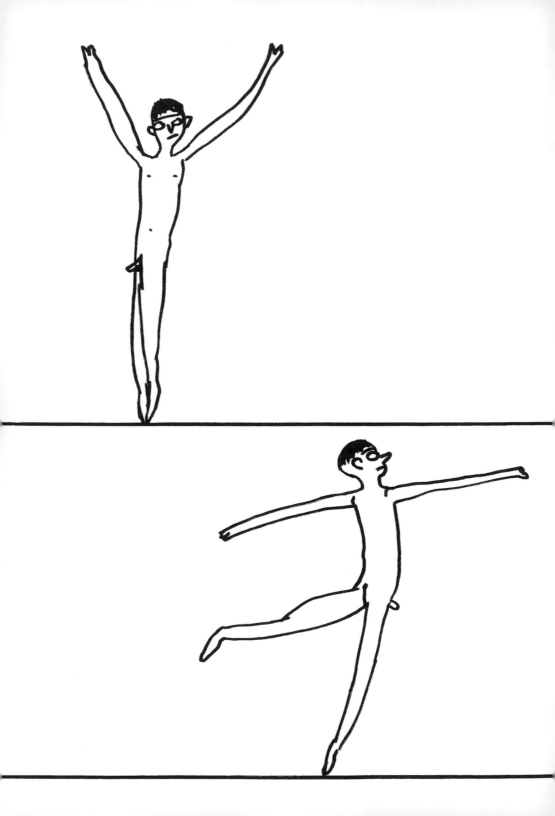

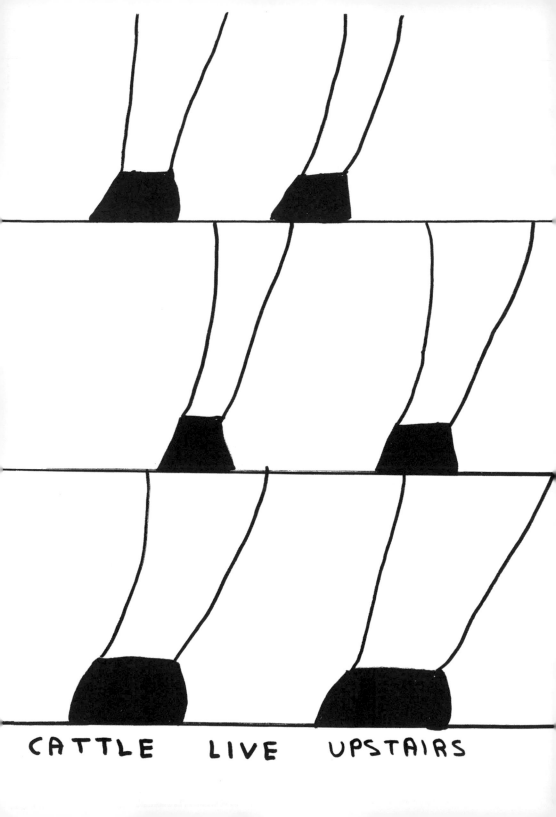

CATTLE LIVE UPSTAIRS

DANCING IN MY CAGE

THE THRILL OF THE CHASE

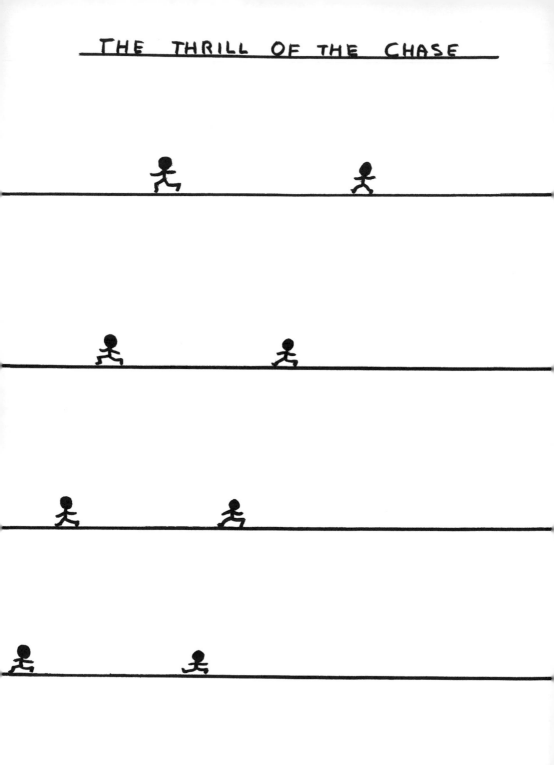

HOW WAS IT?

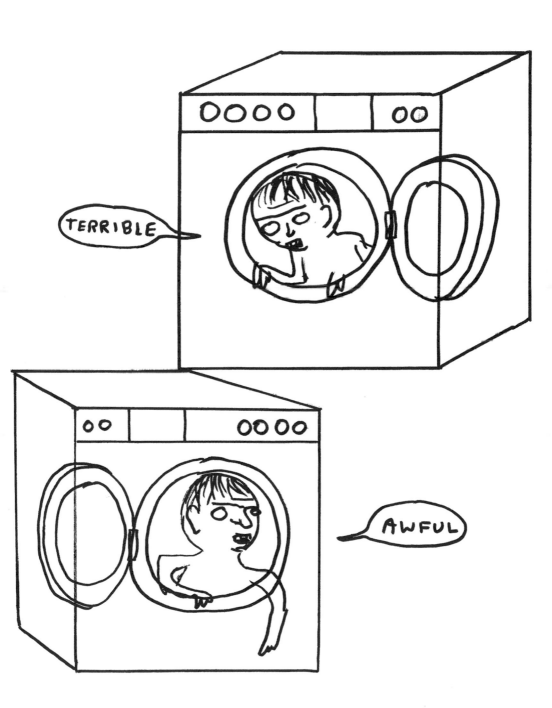

I WAS THERE

I WAS THERE

I WAS THERE

I WAS THERE

I WAS THERE

I WAS THERE

I WAS THERE

THEN

I WASN'T THERE

SIX
SQAURES
SOME
WITH WRITING

SOME

WITH WRITING

SOME

WITHOUT WRITING

CHAPTER

THREE

GRAVES

GRAVE

GRAVE

DENSE

INSTITUTIONS BUILT ON A SLOPE

TIGHTROPE

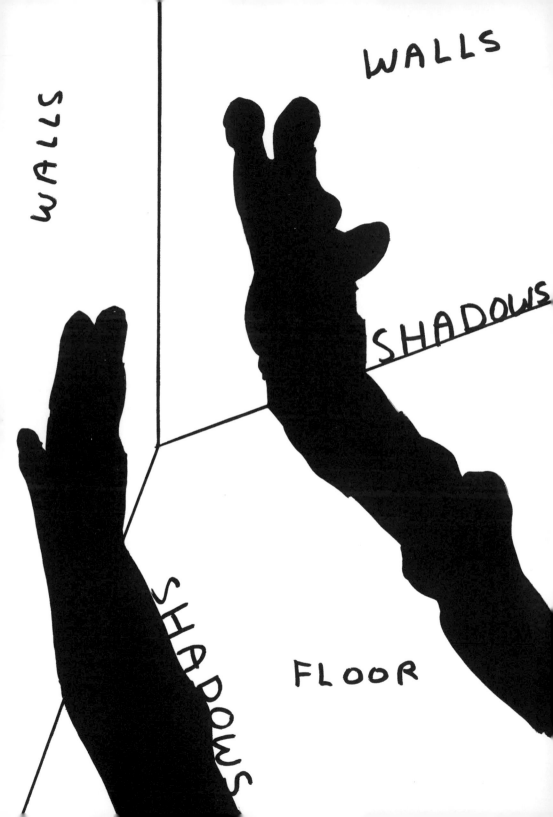

HOLES

HOLES

HOLES

HOLES

HOLES

HOLES

HOLES

HOLES

HOLES

HOLES

HOLES

HOLES

HOLES

HOLES

HOLES

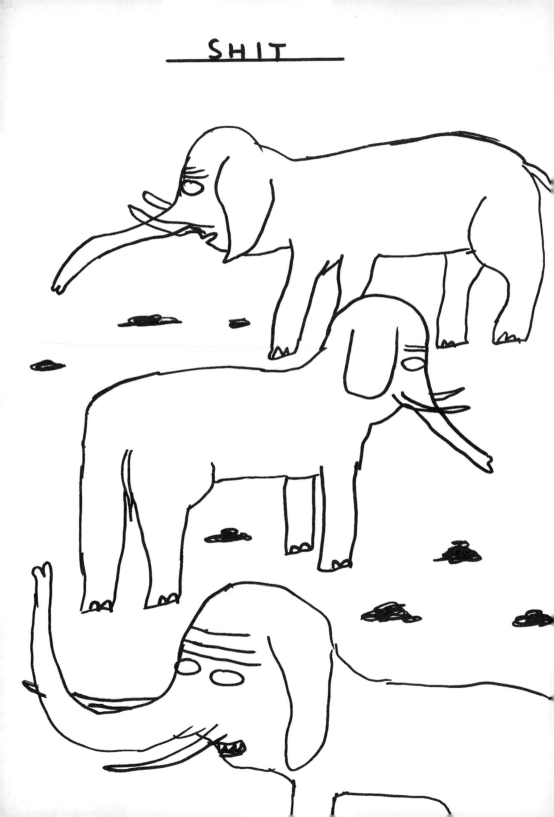

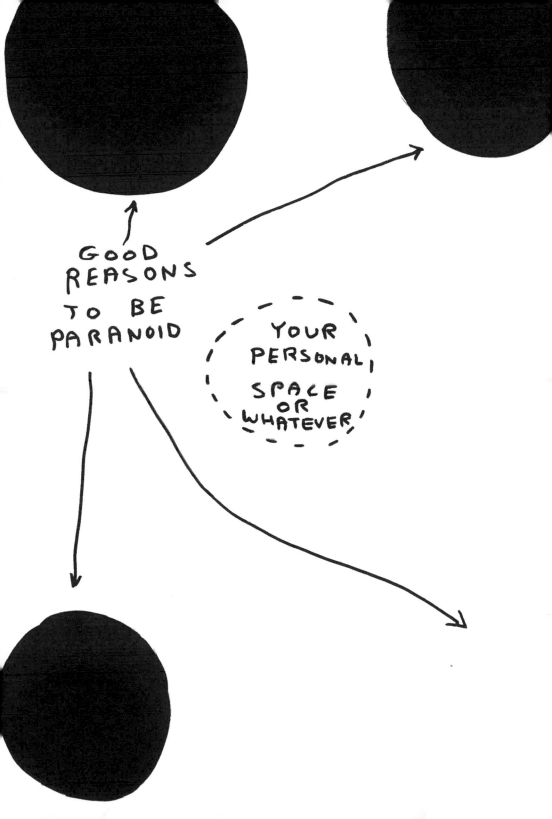

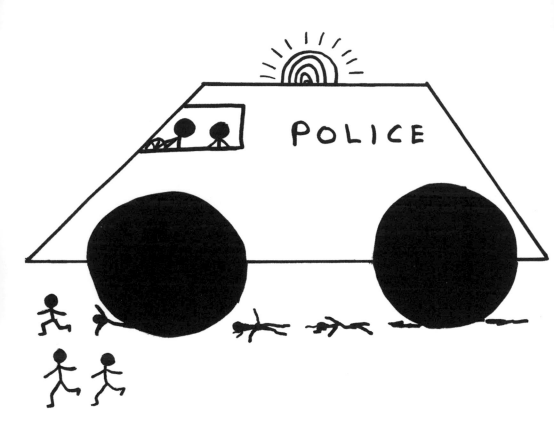

SOMETIMES I WISH I WAS A POLICEMAN

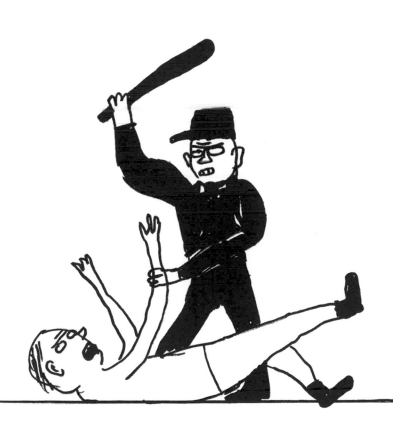

YOU ARE LISTENING TO
SIDE A
YOU HAVE BEEN LISTENING TO SIDEA
FOR YOUR WHOLE LIFE

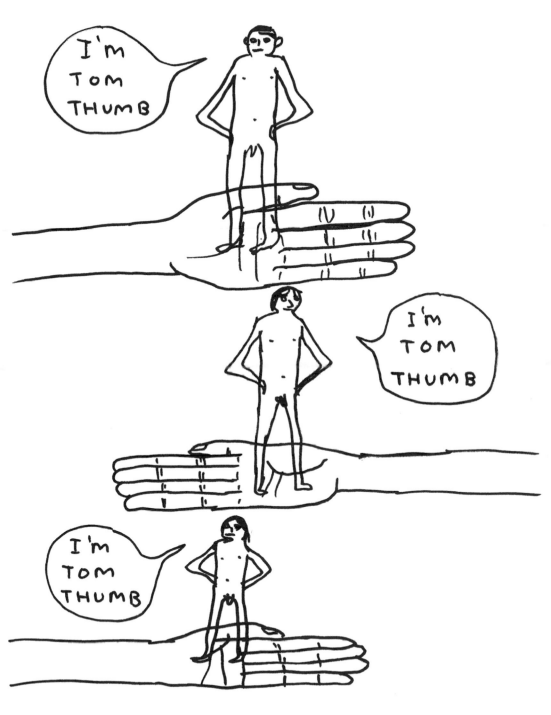

THEY CAN'T ALL BE TOM THUMB
TWO OF THEM ARE LIARS

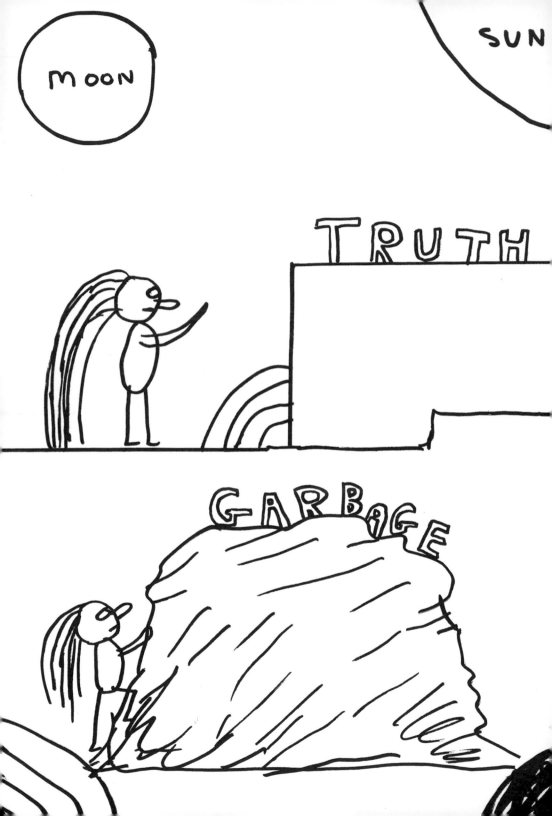

ONE MOMENT THE CHILDREN WERE

 PLAYING HAPPILY

THEN THE NEXT MOMENT THE

COMET STRUCK AND THEY WERE

ALL DEAD.

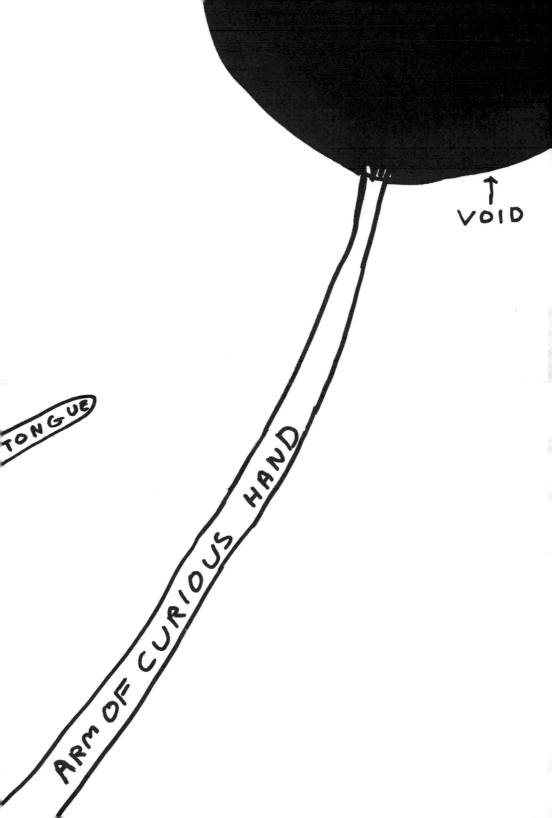

<u>THE BEST</u>

<u>THE WORST</u>

VERY LITTLE DIFFERENCE BETWEEN THEM

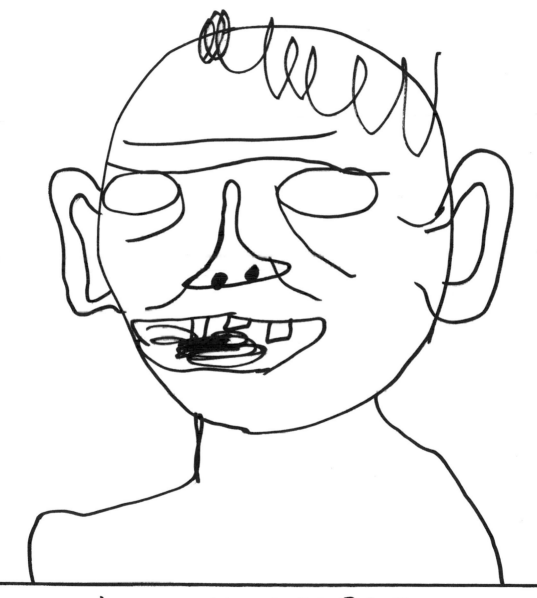

I'M HORRIBLE

TIP OF MY FINGER

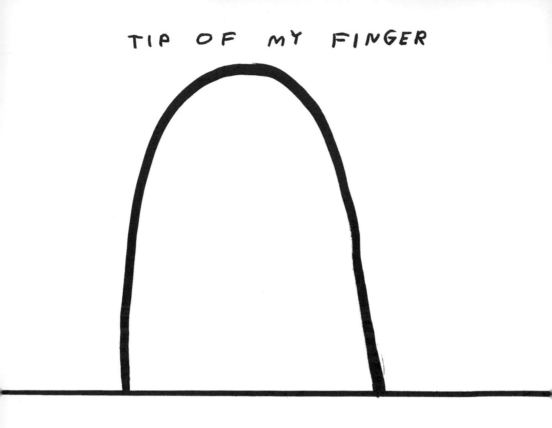

TIP OF MY PENCIL

APPROACHING
THE
RUNWAY

LANDED

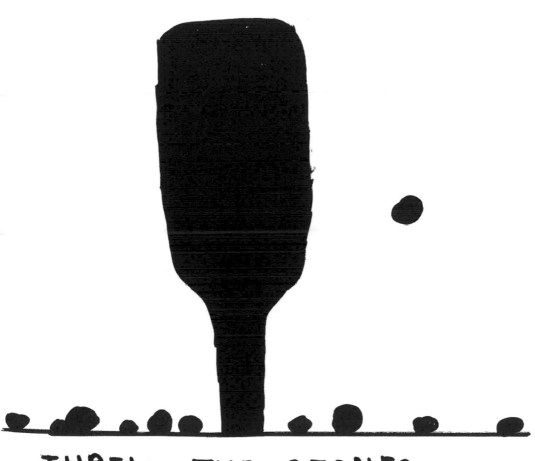

THREW THE STONES
MISSED THE BOTTLE
HIT A DOG

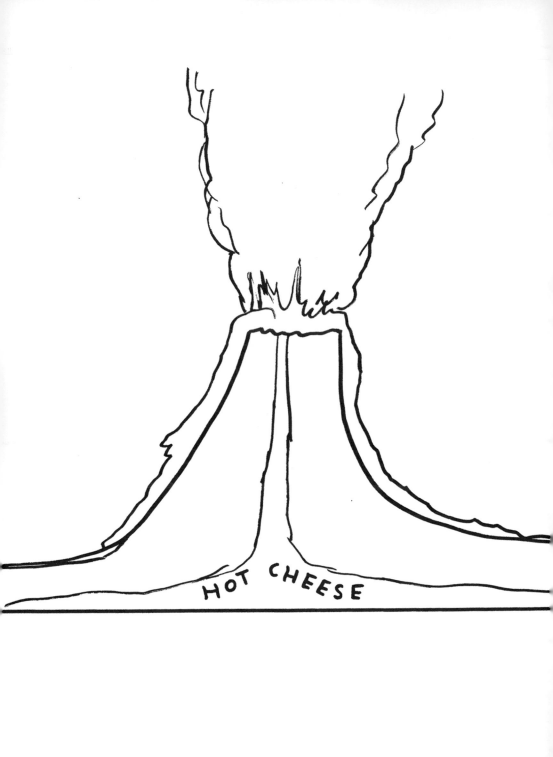

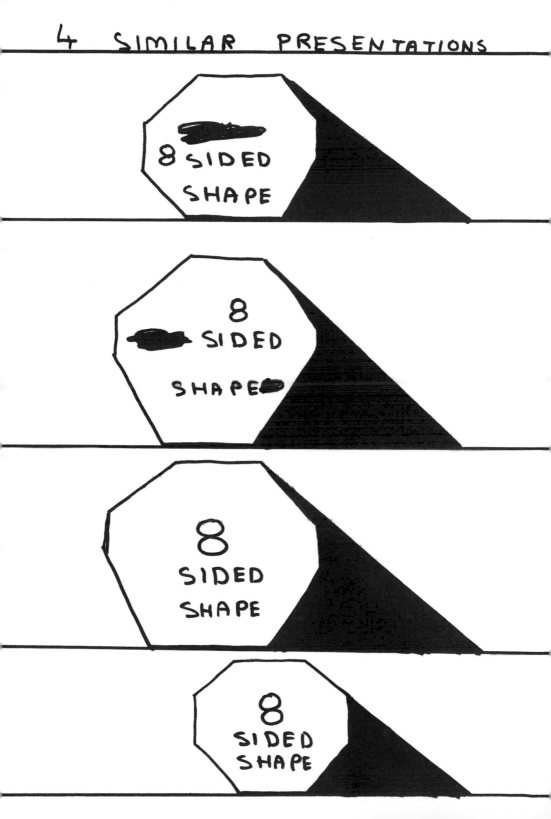

THE START	THE RACE HAS STARTED	I AM WINNING
YOU ARE LOSING	NOW I AM EVEN FURTHER AHEAD	YOU ARE SO FAR BEHIND
IT'S GETTING EMBARASSING	YOU ARE BEING HUMILIATED	THIS ISN'T ENJOYABLE
LET'S STOP THE RACE HERE		

STATUS:

BLOB

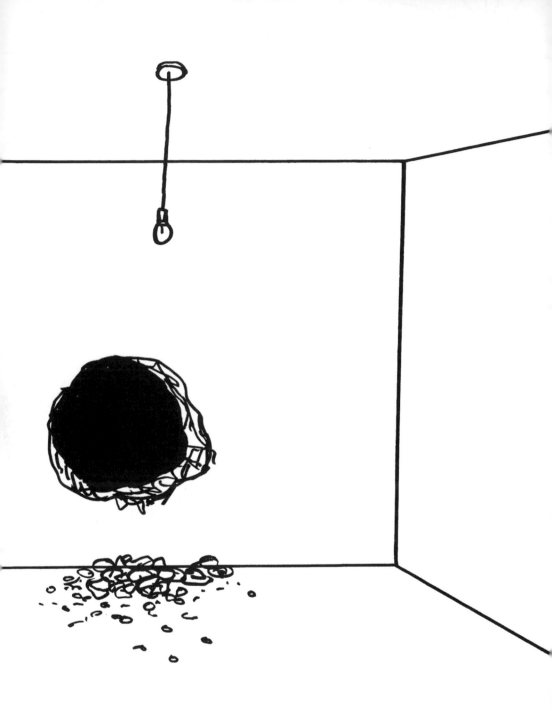

HOLE IN YOUR WALL

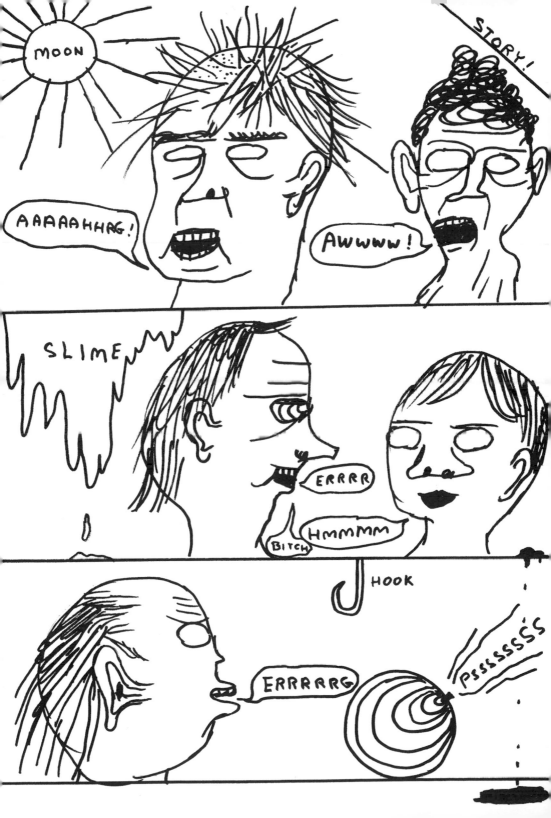

UNTALKATIVE YOUTH WILL BE YOUR GUIDE ON YOUR FINAL JOURNEY

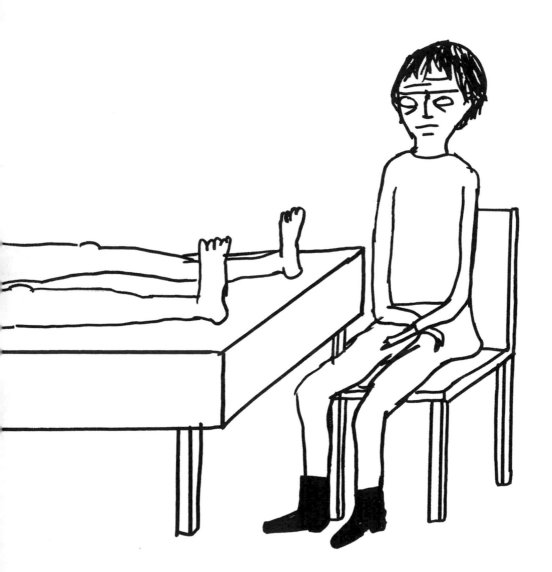

ARRIVAL IN NETHER WORLD

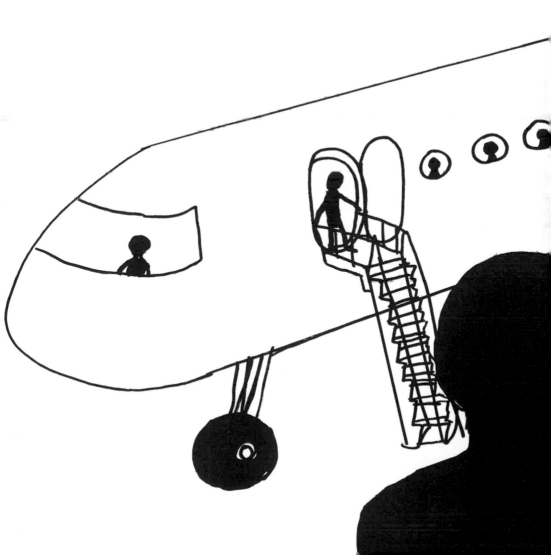

SEE IT ?
NO
ARE YOU BLIND ?
YES

ON STAGE

THINKING ABOUT LEAVING THE STAGE

HAVING DECIDED NOT TO LEAVE THE STAGE BUT HAVING BEEN FORCED TO DO SO BY OTHERS

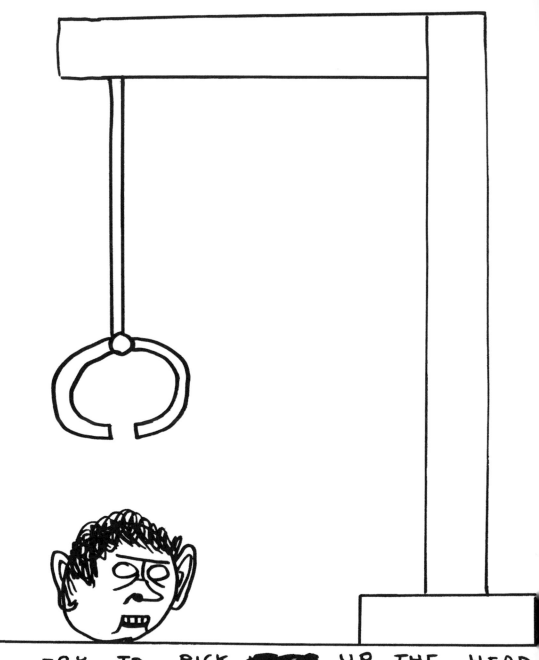

TRY TO PICK ██████ UP THE HEAD
WITHOUT CRUSHING IT

BUT WE WON'T LET IT FALL DOWN
NO WAY

DISCUSSION ABOUT NOTHING
HERE
EVERY NIGHT
ALL WELCOME

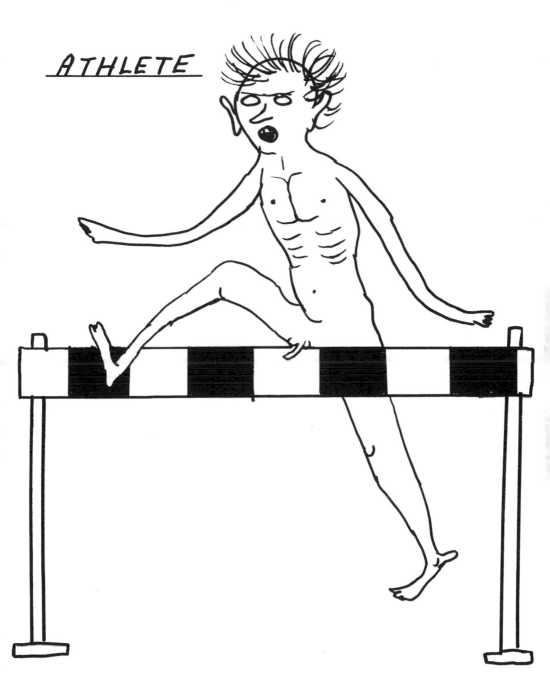

ATHLETE

STAIRCASE

ME

I AM AN ISLAND IN THE OCEAN
NO SHIPS ARE ALLOWED TO VISIT ME
I AM DESERTED OF PEOPLE
I AM WINDSWEPT
I HAVE A CAVE
I HAVE TREES

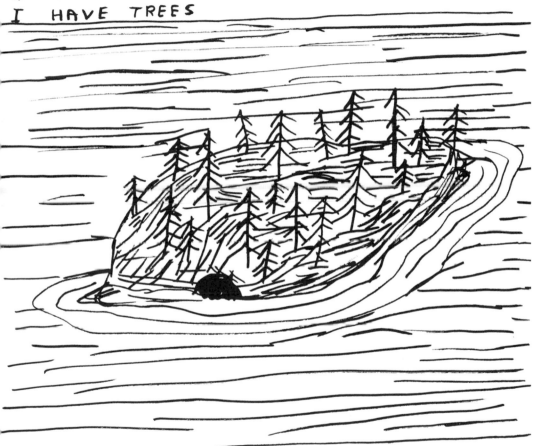

I AM INHABITED SOLELY BY RATS
I AM VERY REMOTE

CUSHIONS

CUSHIONS

GAP

GAP

GAPS
BETWEEN
CUSHIO
NS

CUSHIONS

CUSHIONS

GAP

GAPS
BETWEEN

GAP

CUSHIONS

CUSHIONS

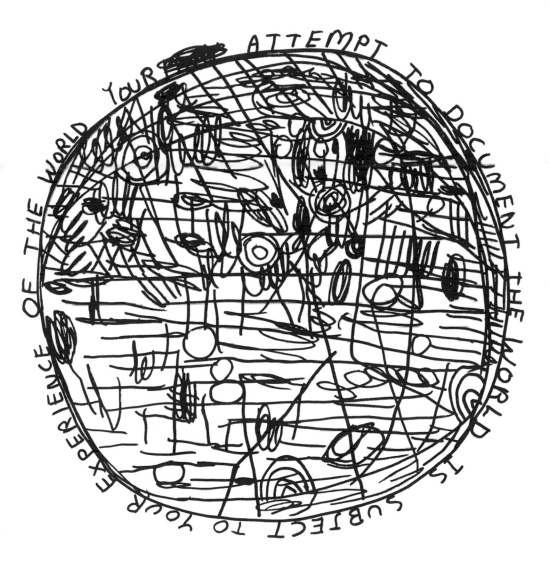

ATTEMPT TO DOCUMENT THE WORLD IS SUBJECT TO YOUR EXPERIENCE OF THE WORLD YOUR

A BUDGERIGAR

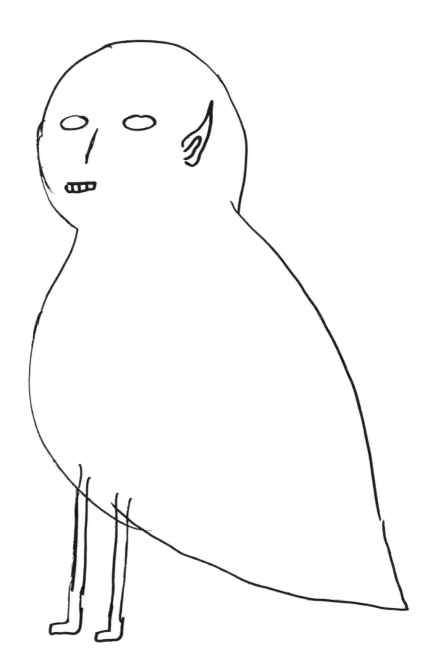

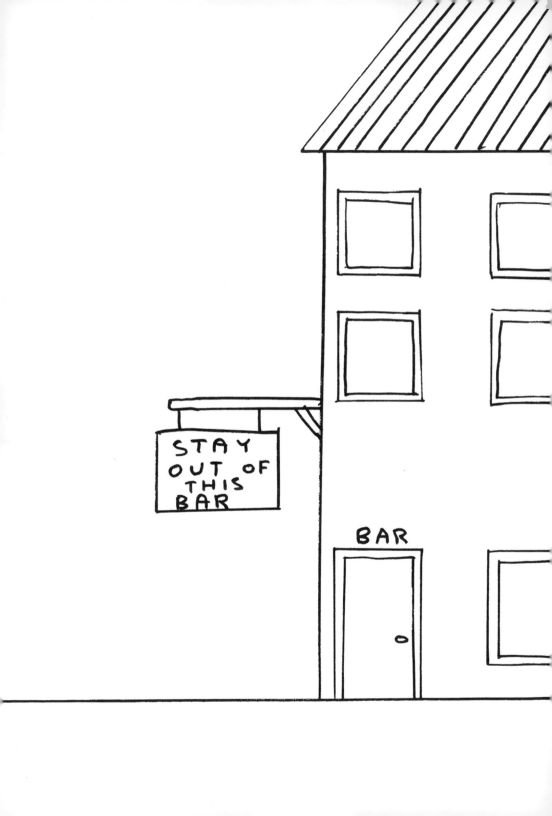

SAVAGES

THEY ARE
THEY EAT EACHOTHER
AND DIRT

OR DO THEY?
WE ARE ONLY TOLD THIS

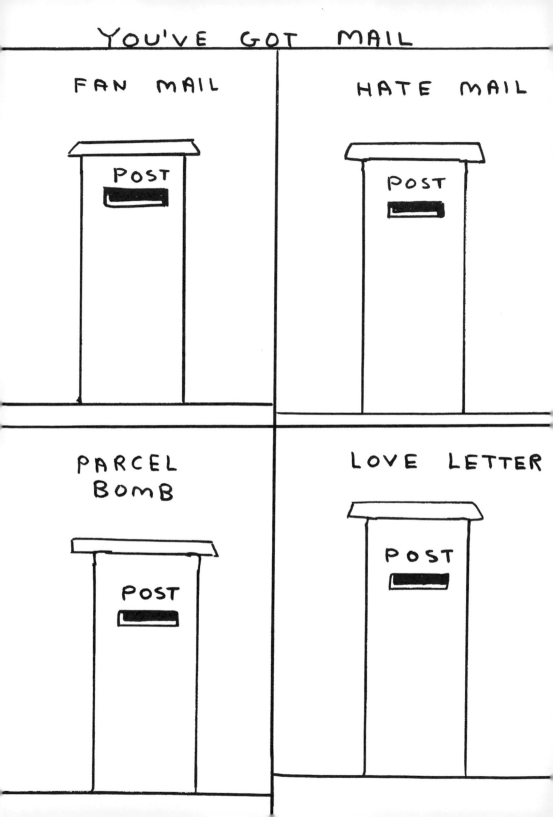

DOESN'T LOOK LIKE ME

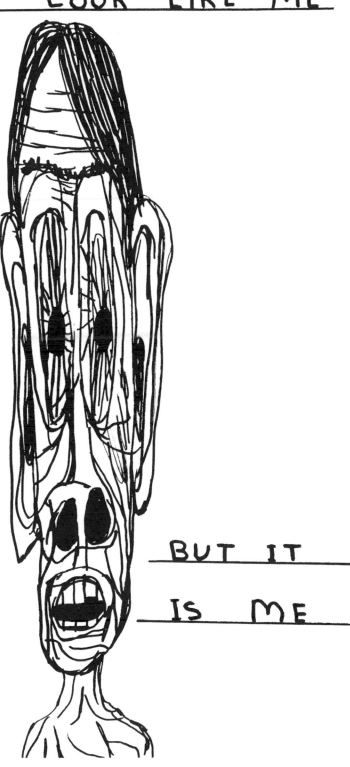

BUT IT

IS ME

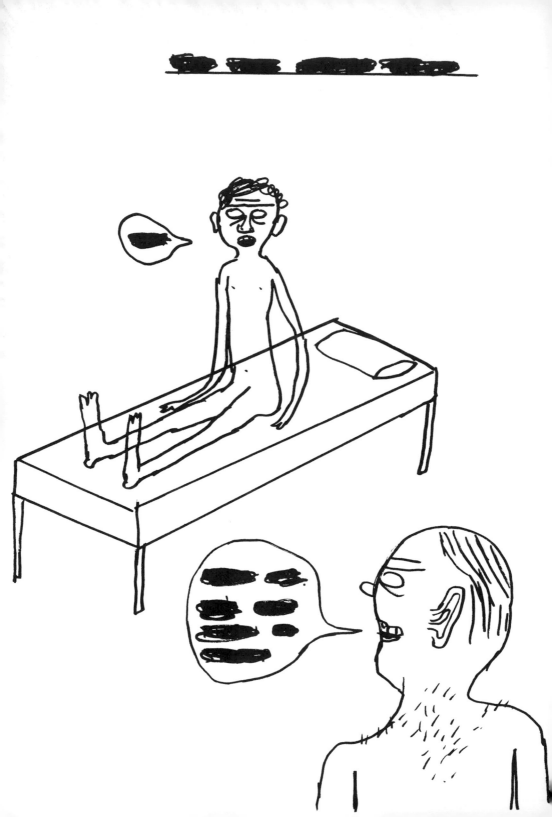

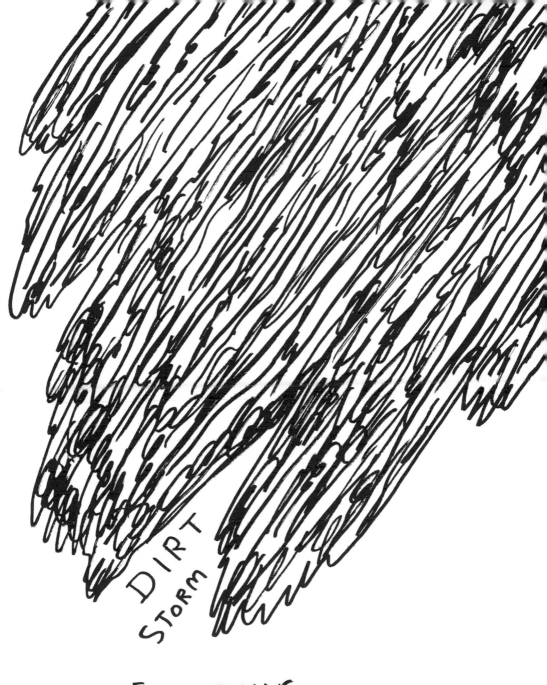

DIRT
Storm

EVERYTHING
WILL BE
COVERED

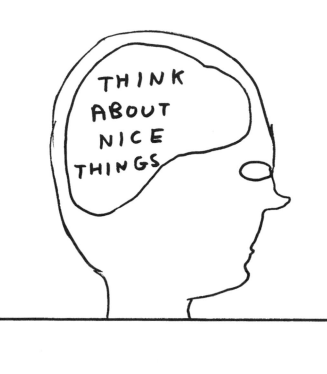

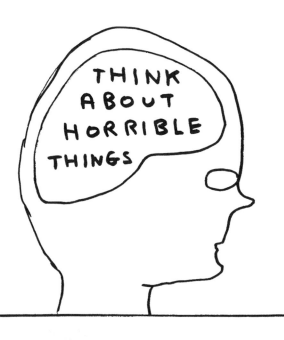

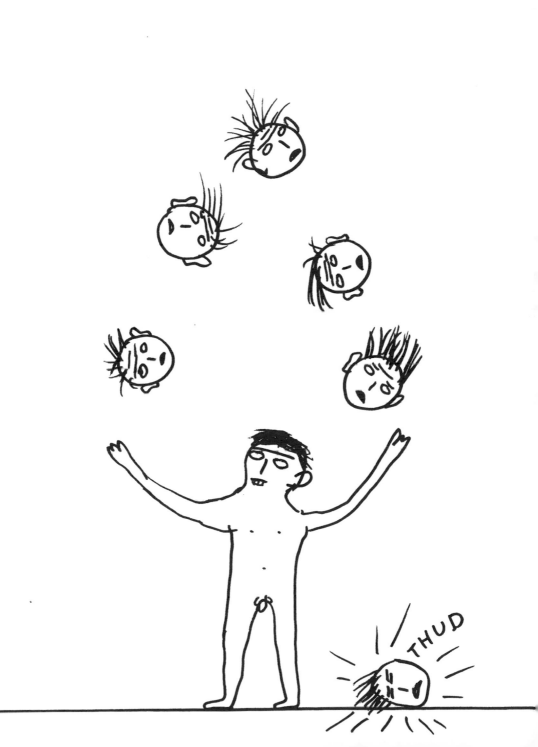

LONG
GRASS

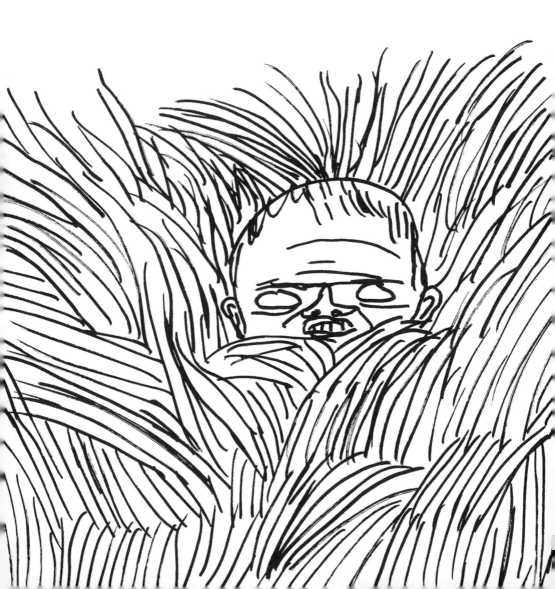

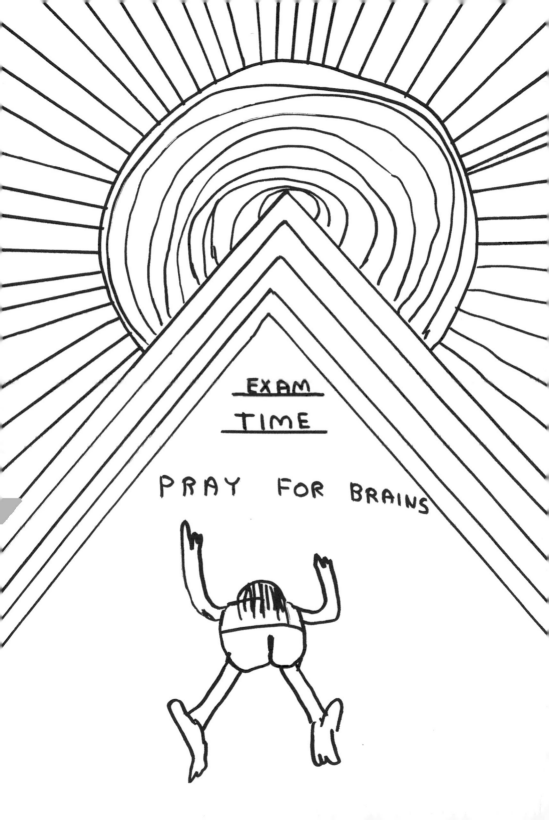

PERFECT MATCH

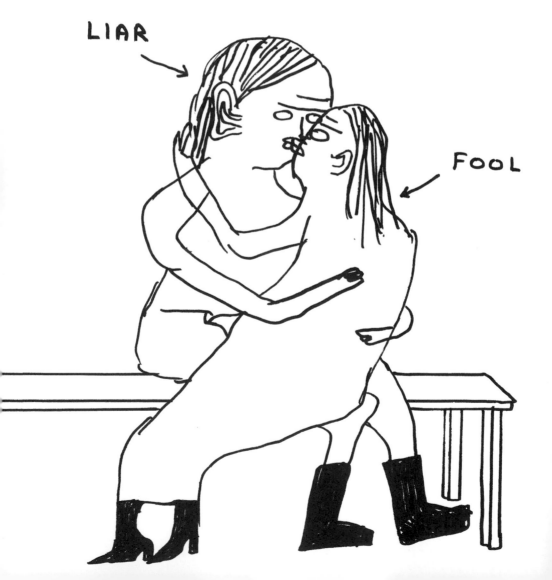

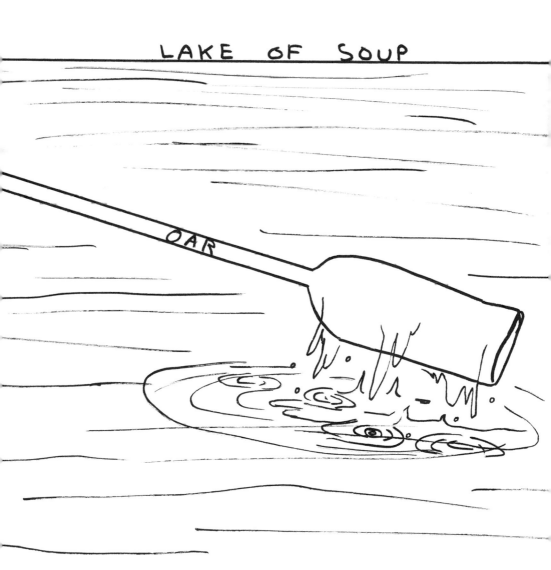

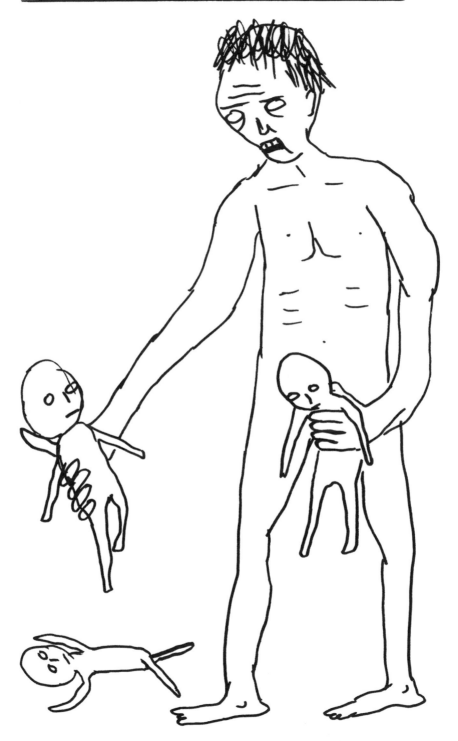

YOU SHOULD EAT SOMETHING

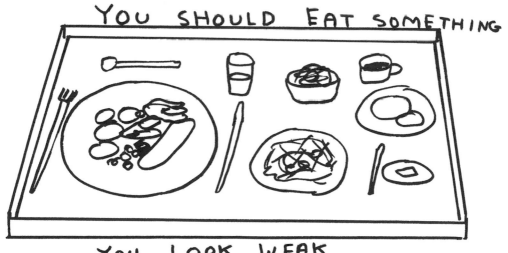

YOU LOOK WEAK

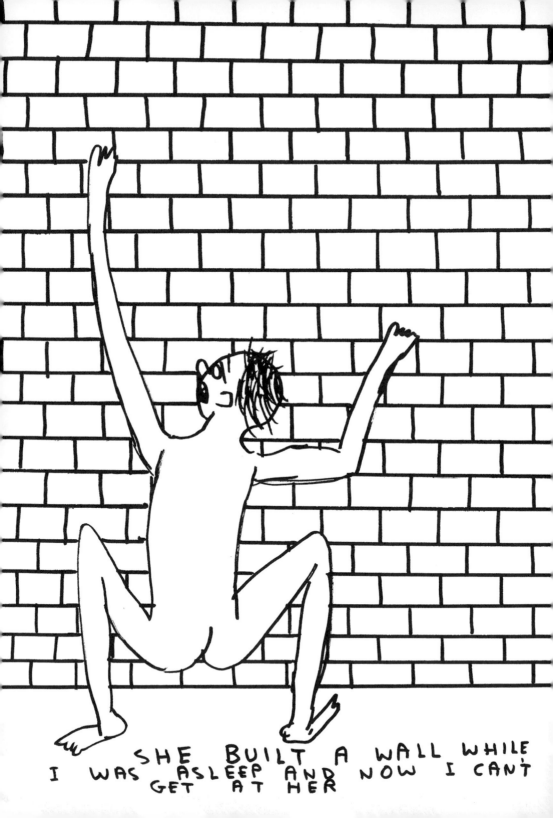

WE ARE POTTERY FALLING TO THE FLOOR

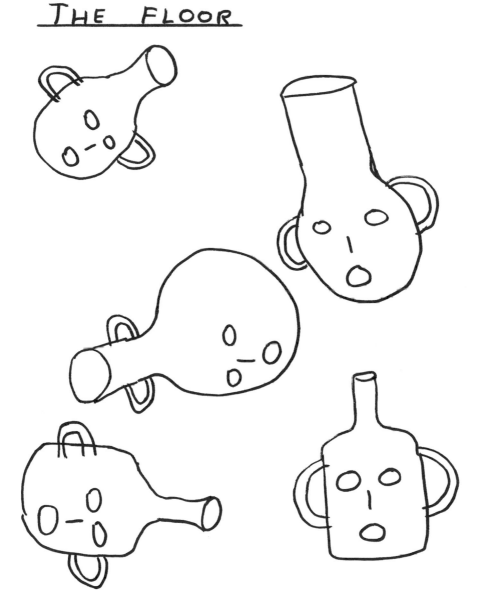

WORD
WINDOW

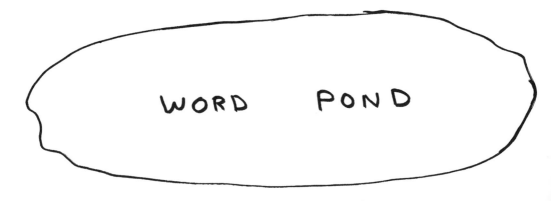

WORD POND

SKIES

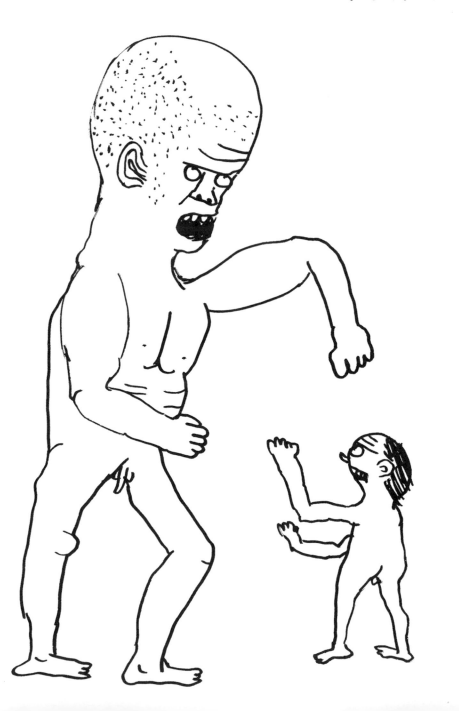

CHAPTER

FOUR

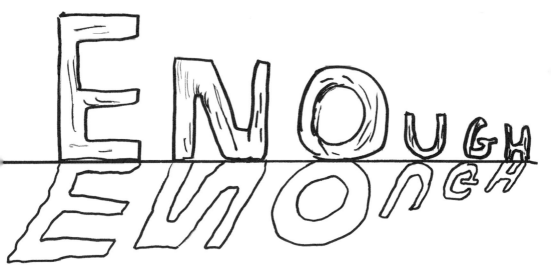

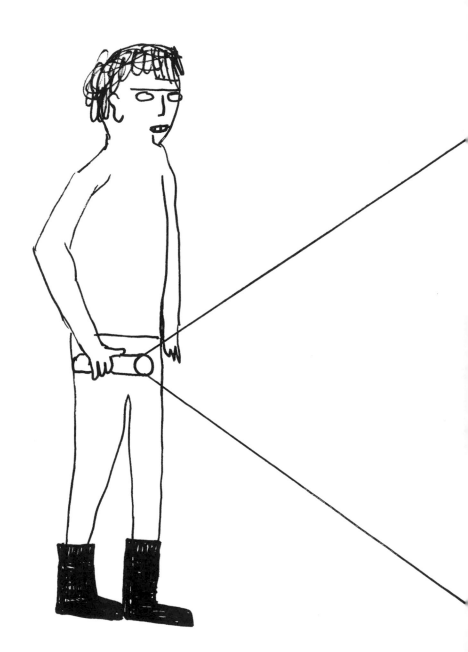

HAIRS GROW ON DEAD ARM

ICEBEBERG ISSA SSYMBOL
IICEBBERG ISA SYMBBOL
ICEBERRGISSASSYMBOL
ICEBERG IS A SYMBOLFOR
ICEBEBERGIS A SYMBOLFOR
ICEBERGISA SYMBOLFOR
THECHAOS
THECHAOSTHATIS
ICEBERGISA SYMBOLFOR THECHAOS
SYMBOLFOR
THECHAOS THATIS ABOUTTOCOME

BEING DRUNK IS GREAT

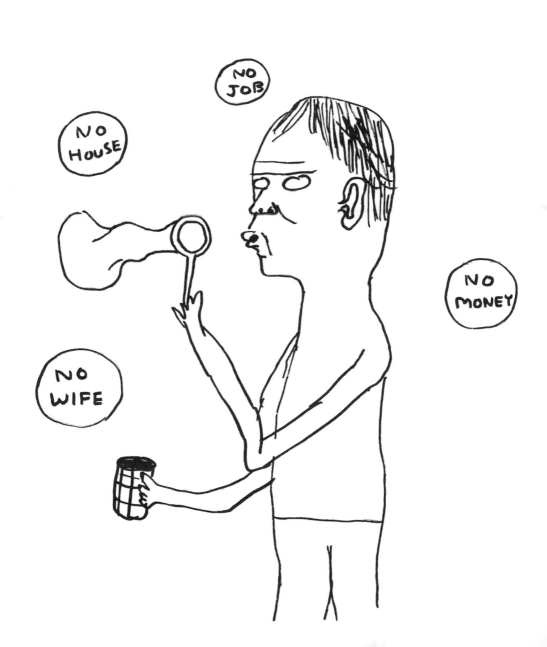

INTERESTING LIFE

SPIN
THE
BOTTLE

BORING LIFE

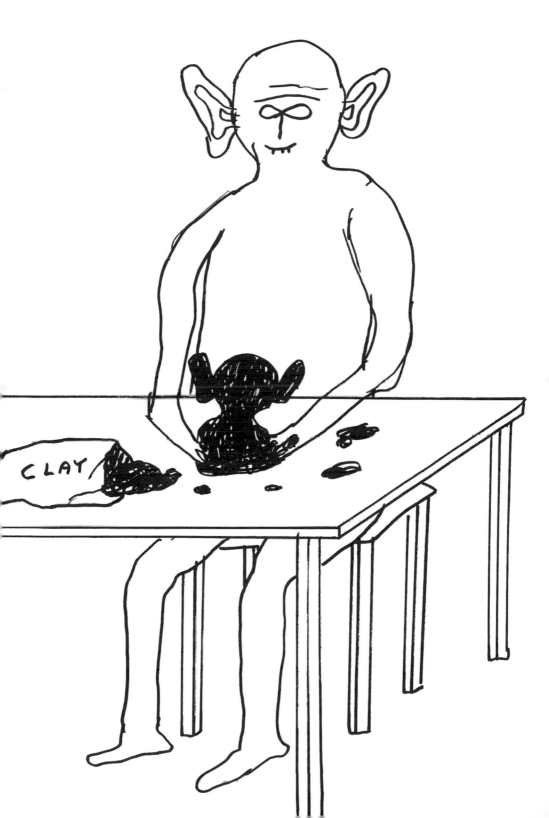

CLAY

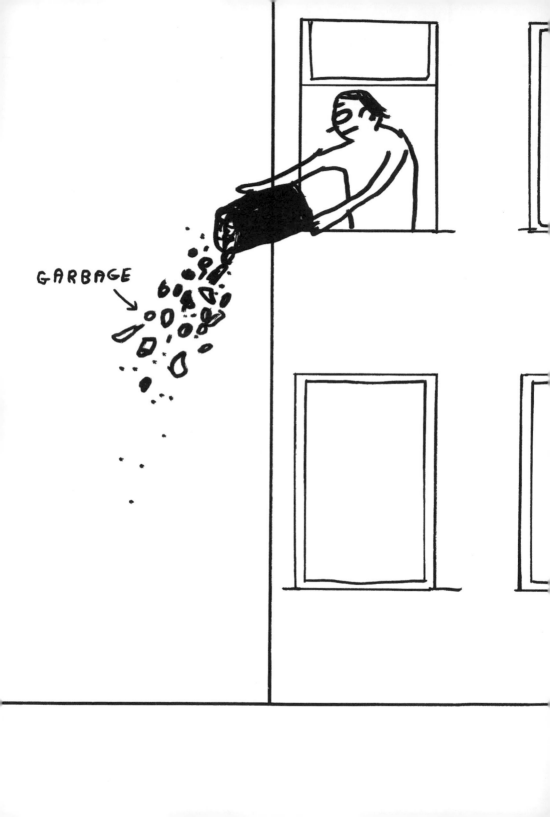

GARBAGE

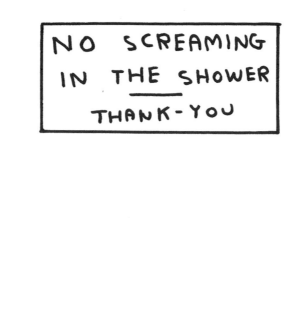

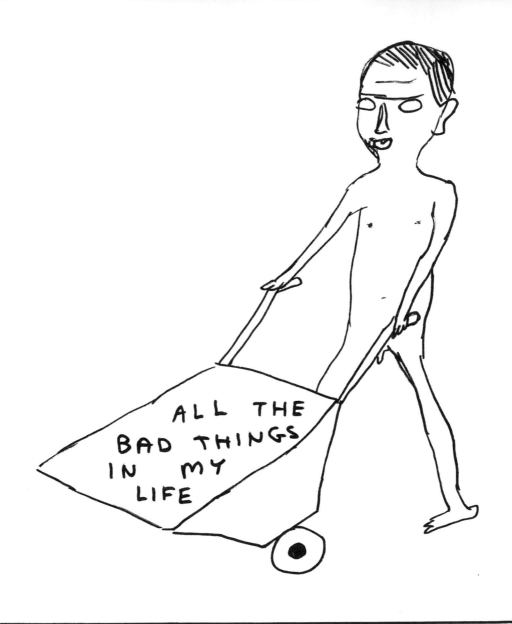

I'm GOING TO BURY THEM IN
THE GARDEN

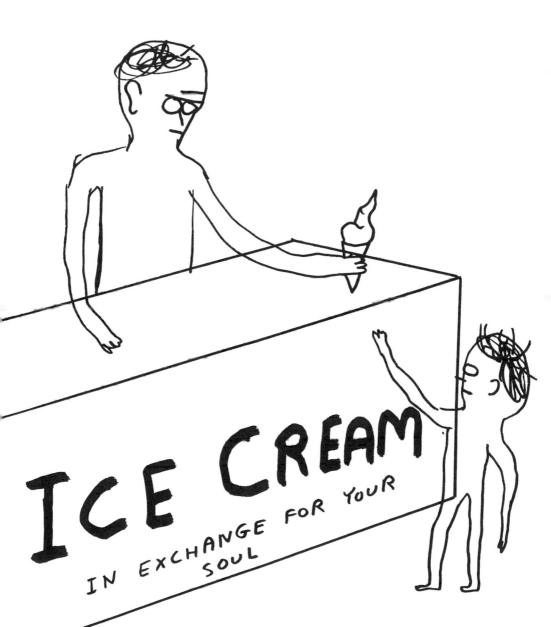

OPERATED UPON BY CHILDREN

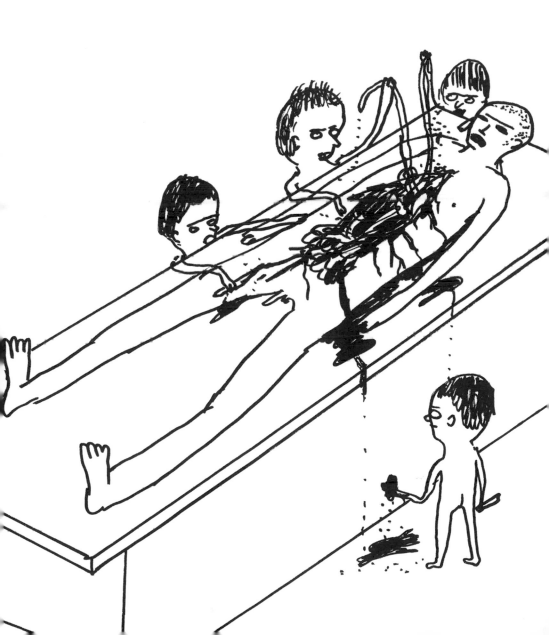

DRUNK

SOBER

FECKLESS YOUTH
TOO LAZY TO ESCAPE
FROM JAIL

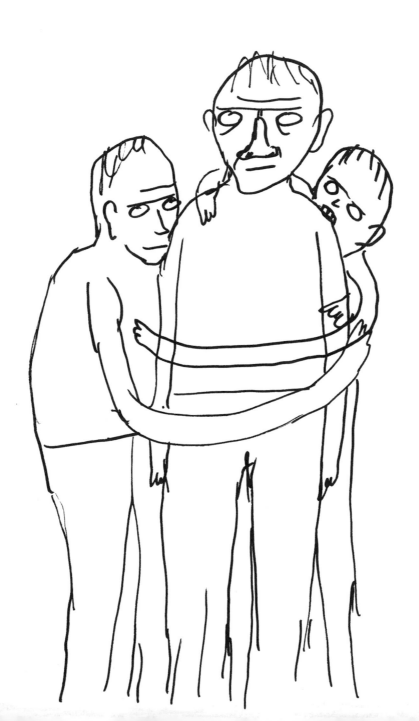

HOW CAN I MAKE YOU UNDERSTAND?

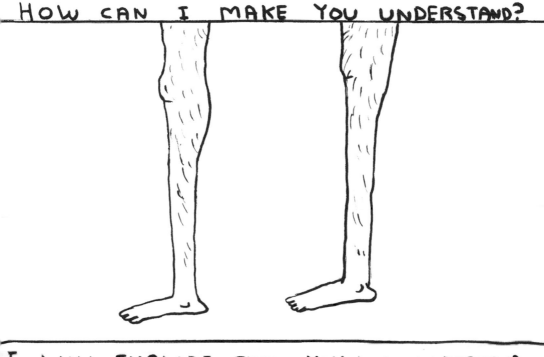

I WILL EXPLODE THEN YOU WILL UNDERSTAND

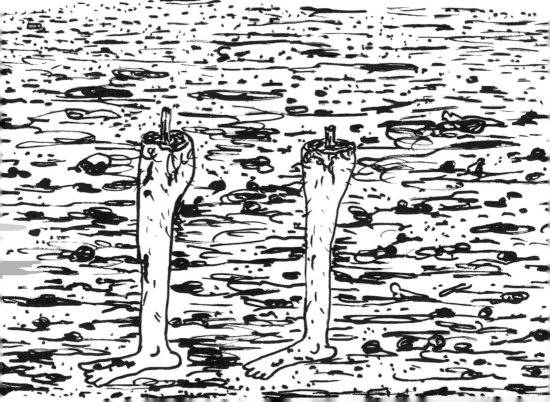

LOST FOR WORDS

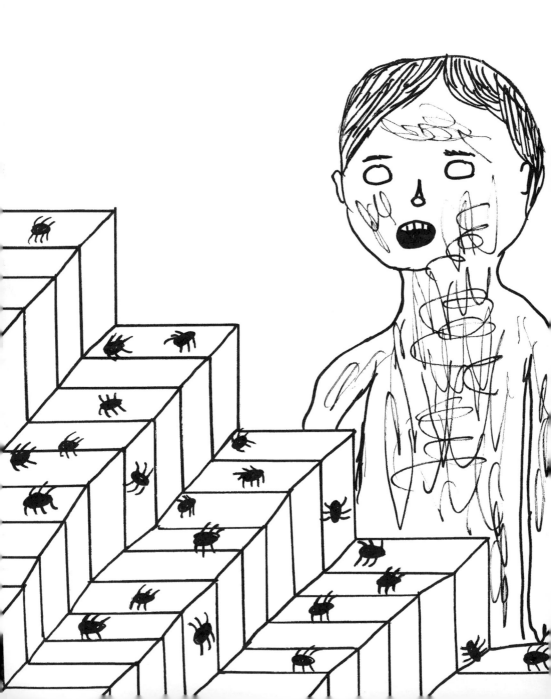

ADDICTED TO POP

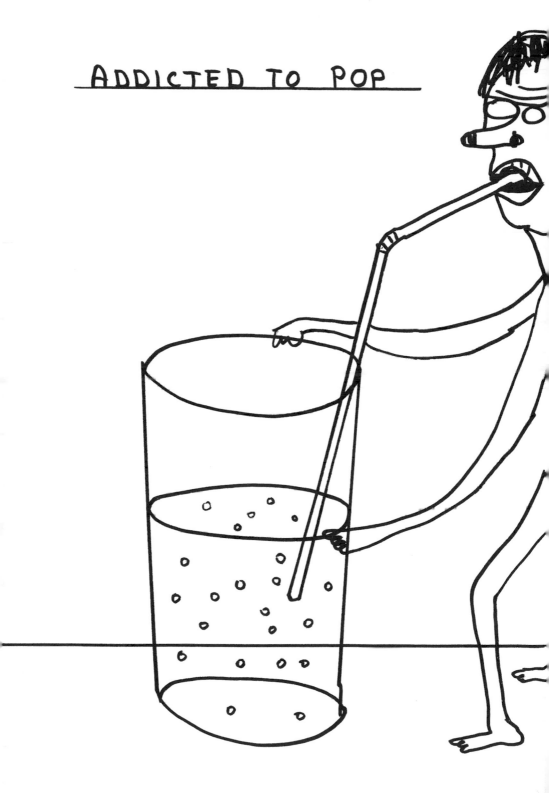

WHO WANTS DRUGS?

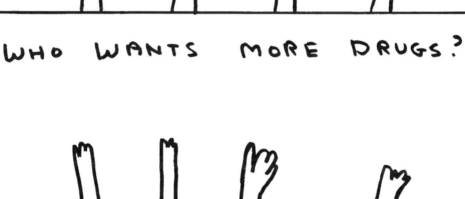

WHO WANTS MORE DRUGS?

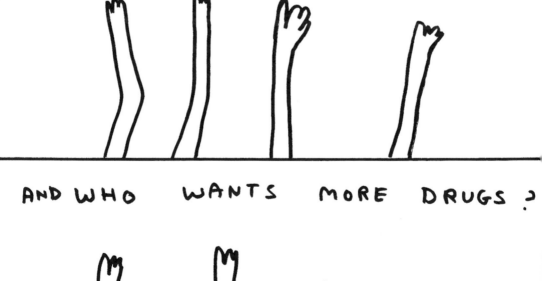

AND WHO WANTS MORE DRUGS?

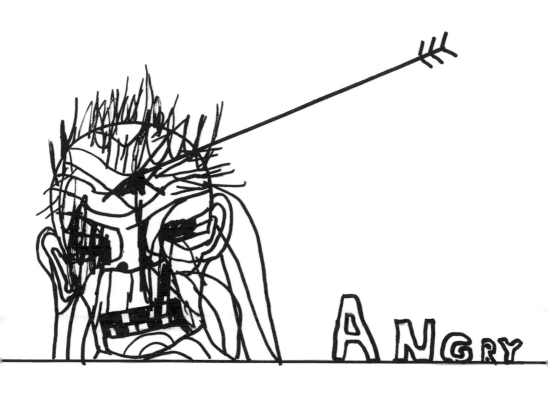

ANGRY

BECAUSE OF THE
ARROW

I FLICK A SWITCH AND

SEE HOW THE TERRIBLE

ATMOSPHERE GOES AWAY

A MISTAKE THAT ANYONE COULD MAKE

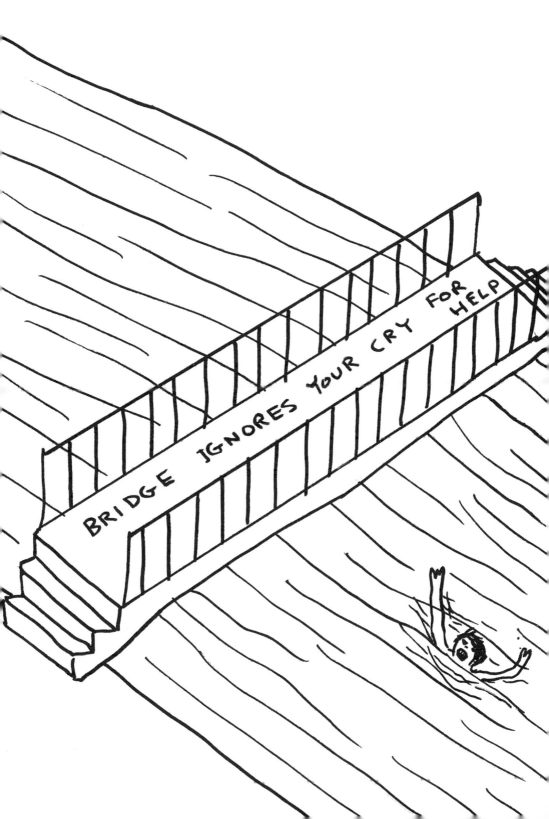

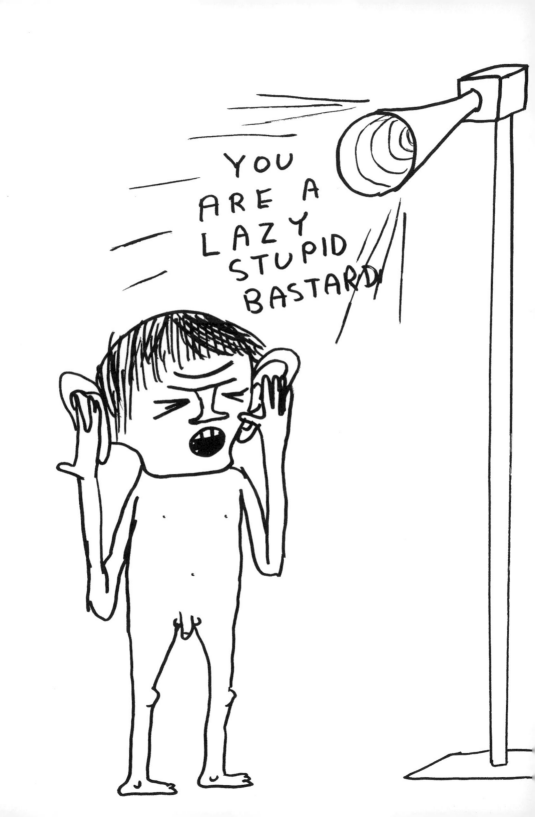

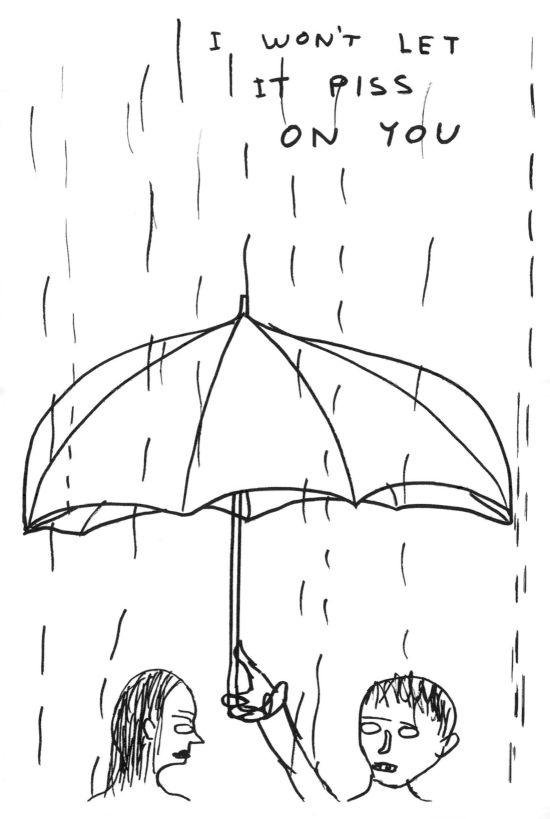

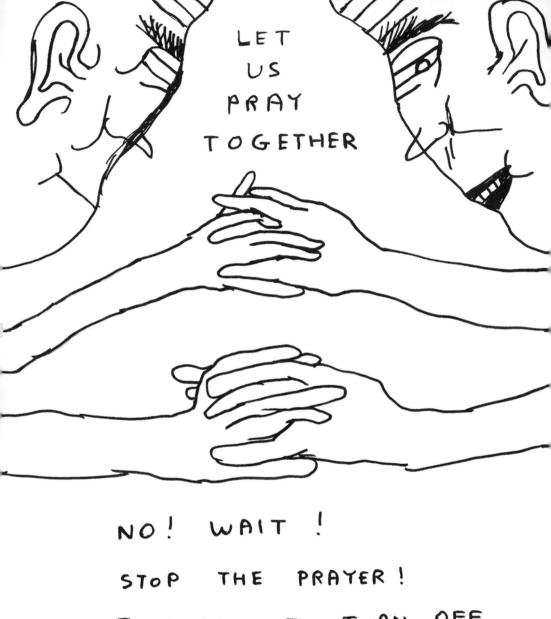

FULFIL
YOUR
POTENTIAL

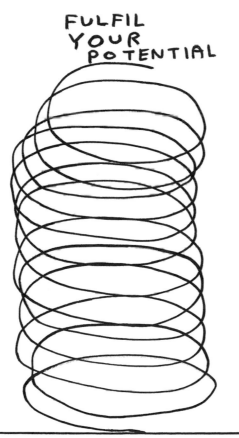

THEN FUCK OFF

THANK-YOU !

YOU'RE WELCOME !

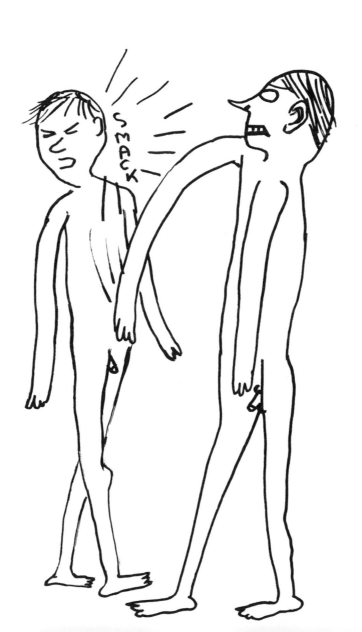

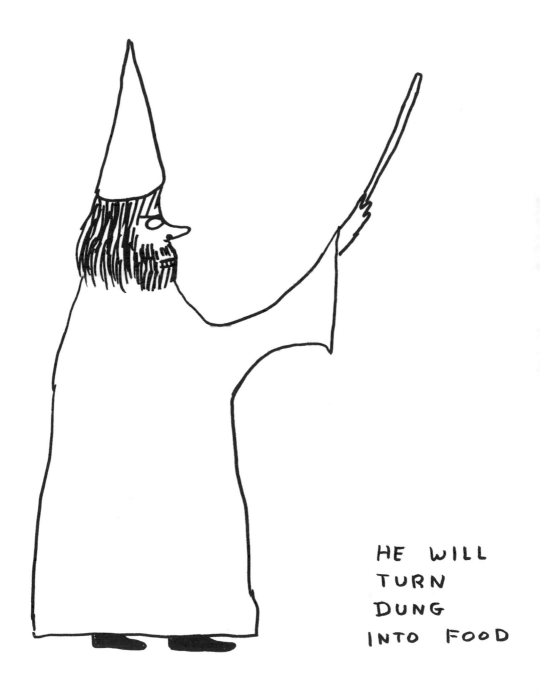

HE WILL
TURN
DUNG
INTO FOOD

FLATTENED

LICK ALL SPOONS IMMEDIATLY

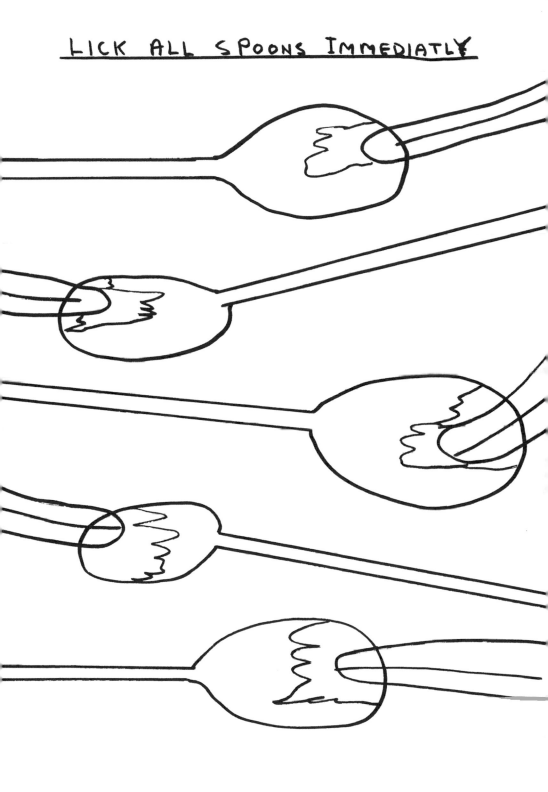

CAN THE CHICKEN SURVIVE WITHOUT
ITS HEAD?
HA, HA, HA! NO, OF COURSE NOT.

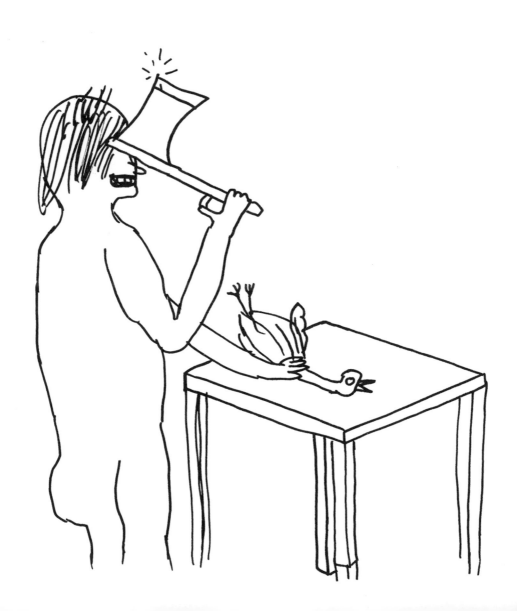

HEY YOU!

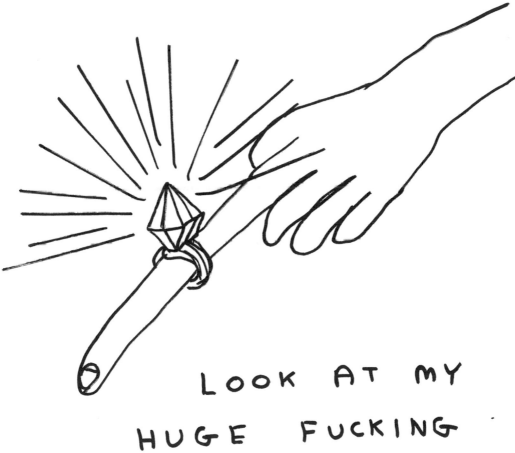

LOOK AT MY HUGE FUCKING DIAMOND RING

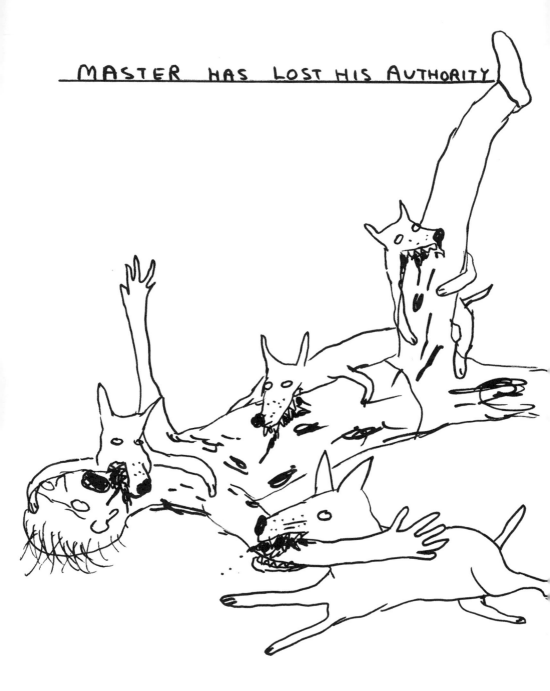

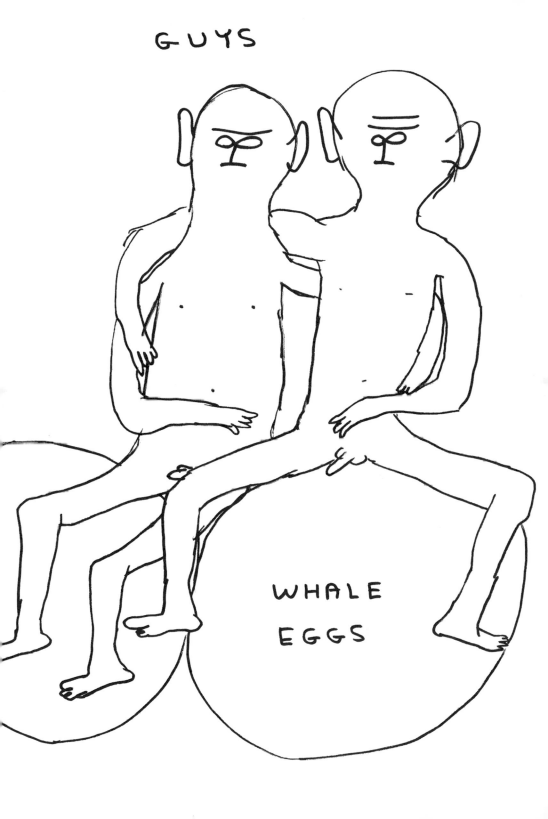

SPORT

MEAT SHOP

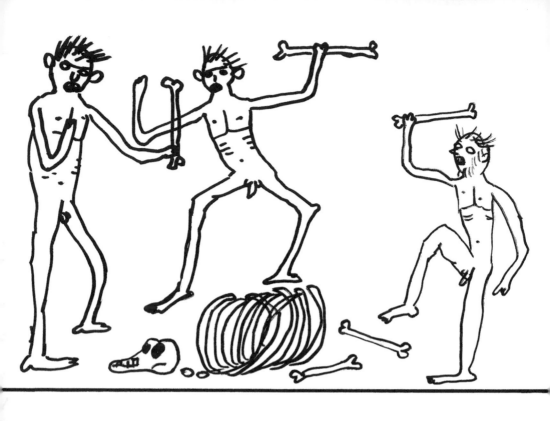

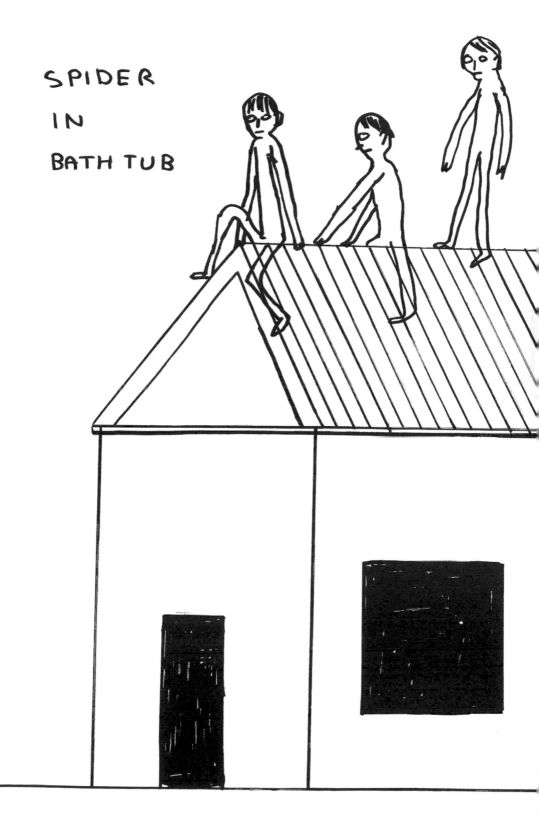

WHEN I WAS A BOY
I WANTED TO BE A VAGRANT
AND NOW I AM A VAGRANT

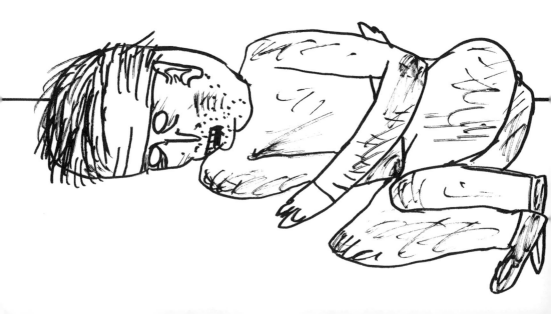

DEAR UNKNOWABLE MAN
PLEASE COMPLETE
THE
QUESTIONNAIRE

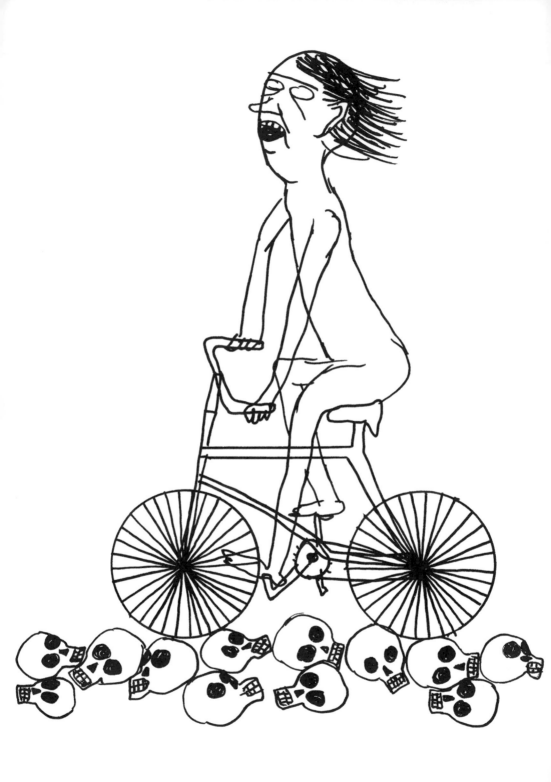

COOKING NOTHING

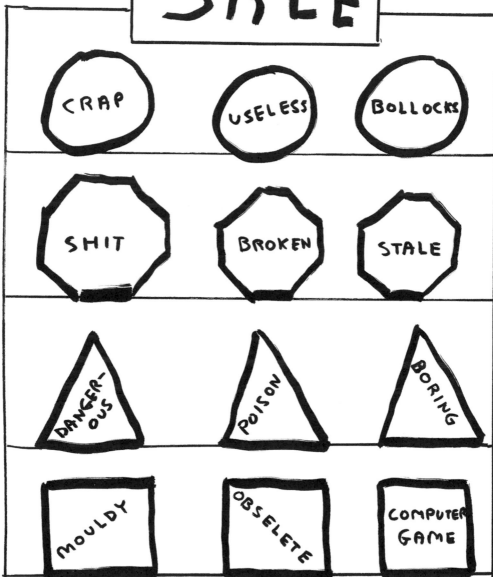

I WENT TO SLEEP AS A BABY

AND I WOKE UP AS AN OLD MAN

HOW DID IT HAPPEN ?

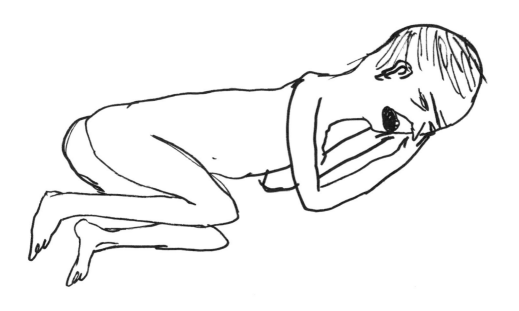

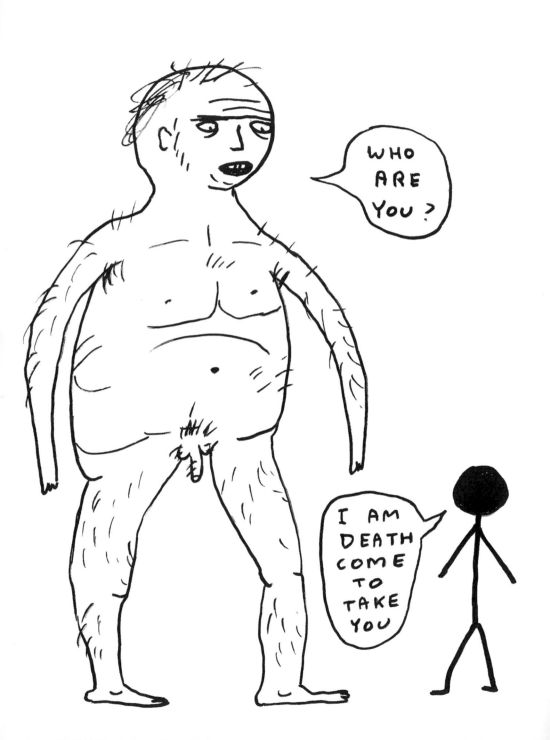

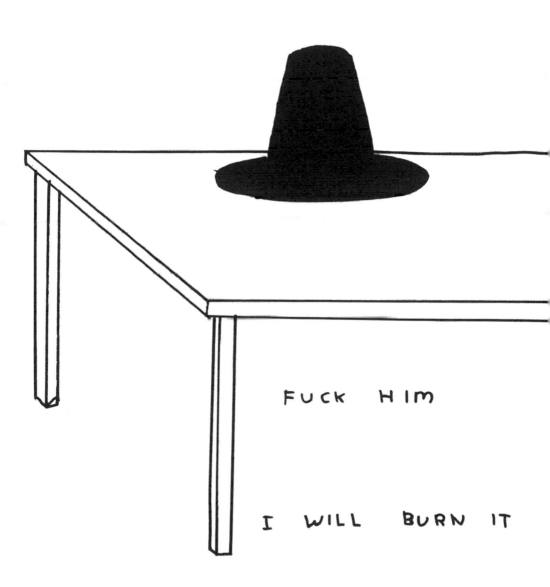

RECIPE FOR CONCRETE

2 ¾ PARTS STONE & GRAVEL

2 ½ PARTS SAND

1 PART CEMENT

½ PART WATER

1 PART LOVE

YOU HAVE ARRIVED AT YOUR DESTINATION

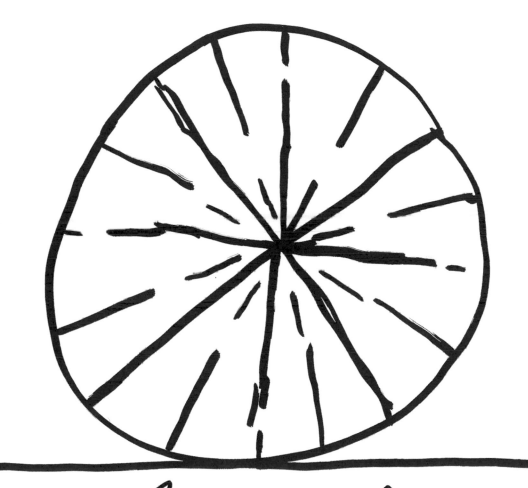

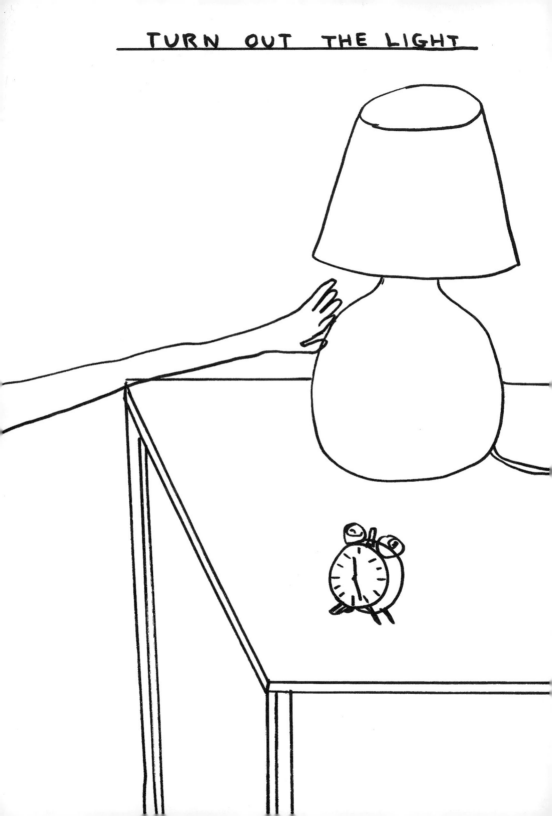